AROUND
MINEHEAD

From Old Photographs

AROUND
MINEHEAD

From Old Photographs

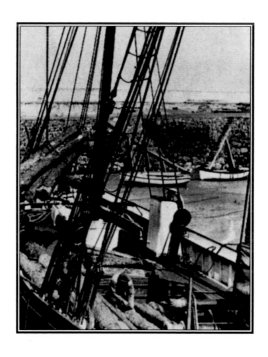

JOAN ASTELL

AMBERLEY

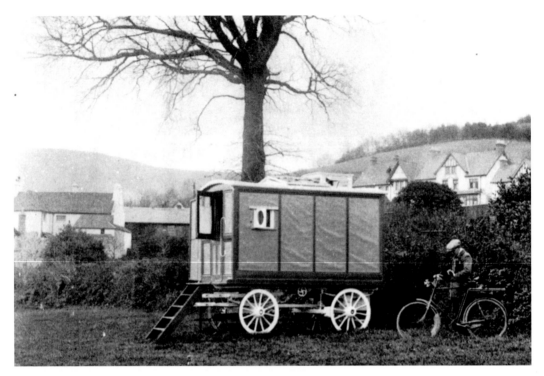

Alfred Vowles outside his caravan in Porlock, 1911.

Title page photograph: *The Emma Louise, c. 1946.*

This edition first published 2010

Amberley Publishing Plc
Cirencester Road, Chalford,
Stroud, Gloucestershire, GL6 8PE

www.amberley-books.com

British Library Cataloguing in Publication Data.
A catalogue record for this book is available from the British Library.

ISBN 978 1 4456 0004 8

Typesetting and Origination by FONTHILLDESIGN.
Printed in Great Britain.

Contents

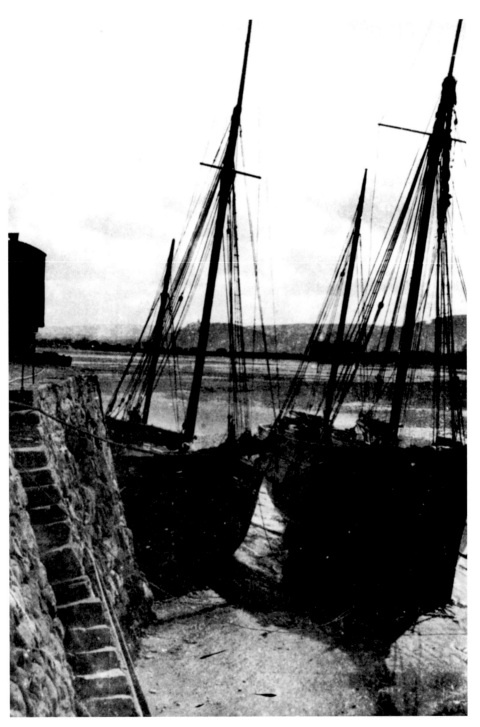

Ketches tied up at the end of the jetty, Minehead.

Introduction

When I purchased the collection of negatives made by photographer Alfred Vowles, at an auction in 1978, I had only a vague idea of what it would lead to. A few of his books were included in the package and from these I could see that he was a Somerset man who loved his county, although he had travelled widely in the early part of his life. It was not until I began researching the man himself, and had the pleasure of meeting his son, that I began to realise the depths to which he did everything in his life.

Vowles was born in 1882 in Stone Allerton, near Axbridge, Somerset, the youngest of eleven children. While his father lived their lifestyle was comfortable, but, when he died three years after Alfred was born, his mother was left in penury, the family money having been spent in 'sport and gaiety'.

Alfred gives a wonderful account of growing up in the rural wilds of Somerset. At fourteen he was sent to the Royal Navy College at Greenwich, where he stayed for a matter of a few months before becoming an office boy in the City of London. He had several jobs in London and a year or two later, through family influence, got a job in the counting house at the Eastman Kodak Company in Farringdon Road, London. The Boer War was now on and, before its end, Alfred had lost two brothers to it: for him it was soon goodbye to London to start work in the company's offices in Berlin where he celebrated his twenty-first birthday. The job eventually took him to Russia, and his memoirs of that country before the revolution make very interesting reading.

Vowles was a countryman, however, and working in an office stifled him. Before 1904 he was back with his mother in Somerset giving a series of lecture tours on 'Life in Russia' with a magic lantern worked by a carbide gas outfit. In 1905 he 'noticed an advertisement in a West of England newspaper, "man wanted to engage as assistant to take photographs in Somerset on a salary and commission basis." A. V. (this is how he always referred to himself throughout the story, which he wrote in the third person) answered and an interview was arranged at Watchet. He cycled over thirty miles there and was engaged on the spot. He was loaned a half plate stand camera with tripod, twelve wooden slides for glass plates and a strong shoulder bag.'

He had not actually studied photography at Kodak but now had the opportunity to learn. Soon working for an employer began to pall and 'he went to Plymouth

to buy a half plate camera and accessories to start business on his own account and from that day for a period of thirty years he vigorously applied himself to the profession of a country photographer and remained his own master; never again would he work in a big town. Armed with his new apparatus he commenced a tour of Devon and Somerset. 'All his journies [sic] were done by bicycle, winter and summer, staying in village lodgings.'

Vowles' autobiography is worth quoting at length:

> He did all his own developing and printing in daylight ... it was really hard work usually done in an unused chicken house, stable, or shed with the liberal use of black light proof curtains with a supply of water from a pump or well poured in for value.
>
> A. V. rode (his bicycle) with the right hand and with the other carried his camera with the tripod slightly extended, hanging from his left shoulder was a heavy bag of half plate slides, usually twelve and he must have travelled thousands of miles like this. Later, on his bicycle he was the first man ever to ride up the notorious Porlock Hill without getting off and to ride down it. A test of physical strength ascending and a test of bicycle brakes descending ... A. V.'s jackets were always fitted with two big inside poacher's pockets ... they were made for him so that he could carry packets of photographs, rolls of film and slides.
>
> 10 April 1910 A. V. rode into Porlock on his six speed bicycle and found temporary lodging at an old thatched cottage where the landlady explained Blackmore wrote part of *Lorna Doone*. That was the beginning of a very busy and interesting career in the Exmoor country lasting for twenty-five years excepting those of the First World War ... No matter how difficult a job might be he never refused it or said 'it can't be done'. He was just as pleased to oblige a poor cottager as the gentry up at the big house.
>
> In 1911 A. V. bought in Devon a large horse-drawn caravan to solve the persistent difficulties of lodgings and dark rooms and in this he did all the developing of plates and later films and made the first proofs by daylight by 'printing out paper', he also did all his writing in the caravan and slept in it summer and winter. It was a tough life ... No meals were taken in the van, not even an early morning cup of tea or a beverage at night. A. V. had all his meals, either at a local cottage or at an inn and scrappy they often were ... there was no fixed heating in the caravan but on very cold nights a small two burner oil stove was lit to humour Jack Frost. For years he never used hot water for shaving and sometimes the lather would freeze on his face. Hot water was bad for the complexion!

In the spring of 1911 Vowles bought a 3A folding pocket Kodak for films the size of a postcard and used it for the next forty years. From his negatives it is obvious that he also continued to use glass plates long after they had been superseded by film, often cutting them to strange sizes. The film he used in the new camera produced postcard-size negatives on nitrate film, highly dangerous but of superb quality. There is hardly any safety film and no 35 mm whatsoever in his collection.

A few months on and the bicycle was not able to cover the distances now demanded, so a new Bradbury 3½ hp motorcycle was purchased. Apart from landing in a ditch at Dunster Steep during the trial run all went well. Vowles made it his business to be in the right place at the right time.

Early in the war A. V. volunteered for military service but was medically rejected because of a deformity of the left thumb which rendered him incapable of correctly handling a rifle. In 1914 he moved, with his caravan, to the military camps in Wiltshire and, at Sutton Veney, built a studio to which hundreds of home and Australian troops came to be photographed. In 1916 he joined up as a Kitchener man and sold by auction his studio, stocks of materials, caravan and bicycle. He was sorry to see them go but the chances of returning from the war were remote.

Vowles did return, however, with a number of pictures of Mesopotamia. Ever adventurous, 'about this time he offered himself in any capacity to the first Mount Everest Expedition but was not accepted on account of lack of mountaineering experience at high altitudes.'

After a short holiday Vowles purchased another horse-drawn caravan and parked it in a field in Alcombe (now the far left of Silvermead) and again set to work. 'It was ideal for sleeping, writing and clerical work, birds built their nests and reared their young close to the windows and sang from the roof ... twice a day A. V. had to pass very close to a hen blackbird as she sat on her clutch, but not once did she stir, there she sat, wild-eyed and watchful.'

In 1923 Vowles bought a new Morris Cowley two seater with a canvas hood, which was never put up except in heavy rain. He went into writing in a big way, and published *Lorna Doone Country*, *The Wild Deer of Exmoor*, *The Doone Valley*, *The History of the Caractacus Stone*, *Dunkery Beacon*, *Nutscale Reservoir – an Appreciation*, together with numerous albums of photographs and articles for magazines and newspapers.

In about 1927 Vowles purchased a house in The Avenue, Minehead for use as a studio. He used this until 1935 when he sold it as a business, leaving his negatives behind him. It was from here that I finally obtained the collection when the last owner retired.

After 1935 Vowles set out, still photographing, on a host of voluntary activities. He was elected on to a committee formed by the National Trust to manage their biggest estate (the Holnicote estates and parts of Dartmoor), and made arrangements for a bonfire on Dunkery Beacon to celebrate the coronation of King George VI. He was also a founder member of the West Somerset Archaeological and Natural History Society, and its Honorary Secretary for eleven years. He also turned his hand to helping Somerset County Council start a list of buildings of special architectural interest.

In 1938 a plebiscite was due to be held in Czechoslovakia and it was suggested that 1,000 men of the British Legion should be sent to keep order during the election. Vowles offered his services, was accepted and set out for Olympia in London where he was fitted out with a navy-blue suit (with double-breasted jacket), socks, black army boots, knife, fork, spoon and enamelled plate, boot polish and brushes, hair brush, toothbrush, cake of soap, tie, overcoat and peaked cap and a walking stick. The men got on to a boat at Tilbury but never sailed as all was cancelled; they kept everything but the overcoats and peaked caps.

With the Archaeological Society in 1938, Vowles started to excavate Burgundy Chapel on the west Somerset coast. The work was halted because of the outbreak of war. Answering the call to arms he joined the Home Guard, being the first to volunteer in Somerset. Soon he was attending parades and defending the moor

with crowbar and pitchfork. When the tanks and soldiers took over the moor he erected large wooden 'Keep Off' signs on sites of archaeological significance. Most were left untouched.

The culmination of Vowles' work in the district came in 1947, a few years before he left, when Tarr Steps needed reconstruction and he undertook the work himself. The story is told on page 103.

At the end of the war, aged sixty-three, Vowles planted the Union Jack on Dunkery Beacon; after a few more years he left the district for ever. This, his wonderful collection of photographs, provides interest and nostalgia for all who love Somerset.

Joan Astell

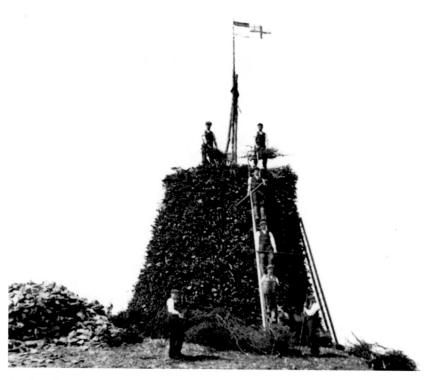

Dunkery Beacon, 1911.

one

Minehead

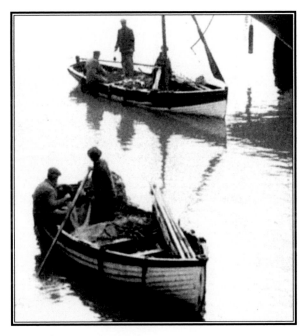

Fishing boats at Minehead.

Minehead's North Hill, before 1887. The field patterns are clearly visible and the trees which now cover it are not yet planted; missing too are the sea wall and promenade. The photograph was taken from where the Queen's Hall now stands.

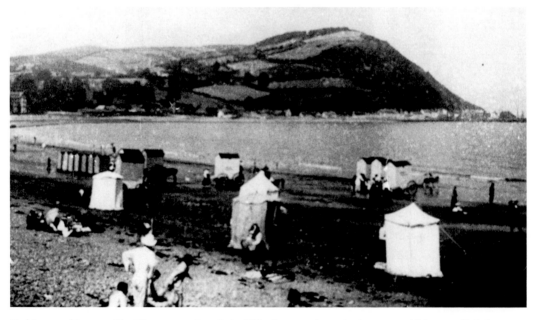

Bathing machines on The Warren, *c.* 1890. It is difficult to see how the horses could have pulled the machines out far enough to cover the bather's knees before sinking into the soft sand. In 1935 the Home Office suggested to the council that it should allow undressing on the beach, like most other towns, but the idea was turned down.

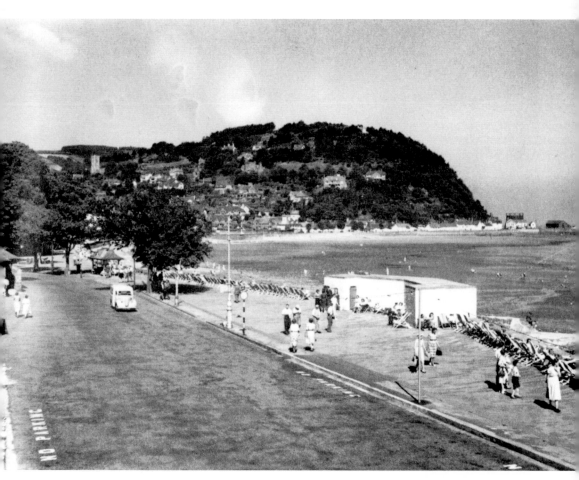

The seafront, *c.* 1946. Clearly visible is one of the fortifications that were built along the seafront and disguised as innocuous promenade buildings. This long white building has now been demolished although the building replacing it is often mistaken for the machine gun post. Outside it can be seen a group of people using the 'print your name' machine which delivered a little aluminium name plate; despite the shortage of aluminium this machine was stocked throughout the war. In the background can just be made out the stakes driven into the beach to hamper an invasion attempt.

Quay Street, 1905. When the pier was built in 1901 steamers began to unload passengers at the rate of 1,000 per boat. Horse-drawn vehicles waited to take them to town and built up traffic jams of immense proportions in this narrow street. By 1910 it was decided to demolish the buildings along the right-hand side of the road to ease the situation.

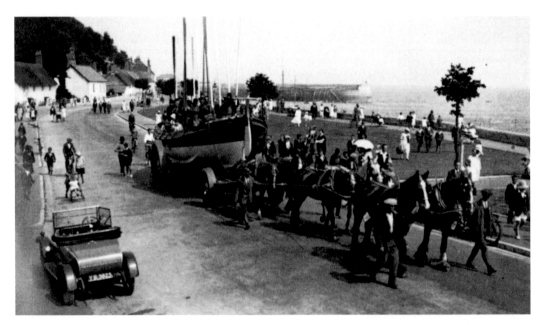

The single-sided Quay Street, 1927. Here is the *George Leicester* lifeboat being paraded shortly before being replaced by *The Hopwood*. She made one further rescue before the change, when the *Silver Spray* capsized during the regatta.

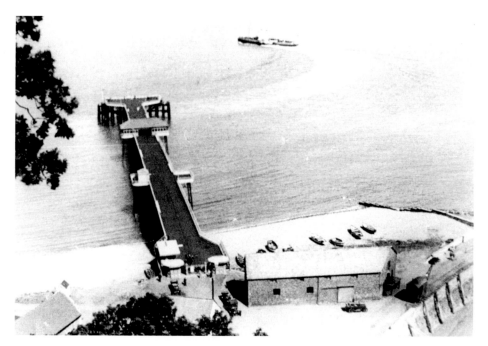

The pier, *c.* 1905. In 1901, amidst great toasting and feasting, Mr G. F. Luttrell of Dunster Castle opened the new promenade pier situated to the west of the jetty and opposite the gas works. With its two-tier landing system, shown in the bottom photograph, it could unload and pick up without waiting for the tides. Its success was short lived but it managed to survive until May 1940 when it was demolished by order of the War Office. The end section can still be seen with a tangle of twisted girders marking its supports.

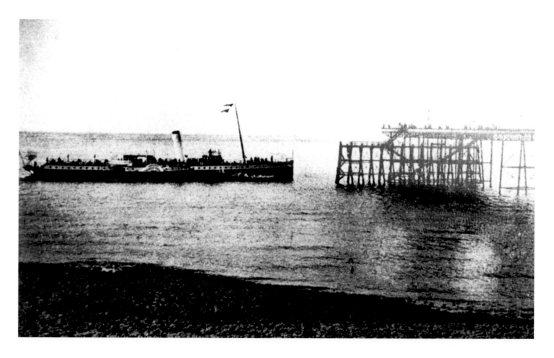

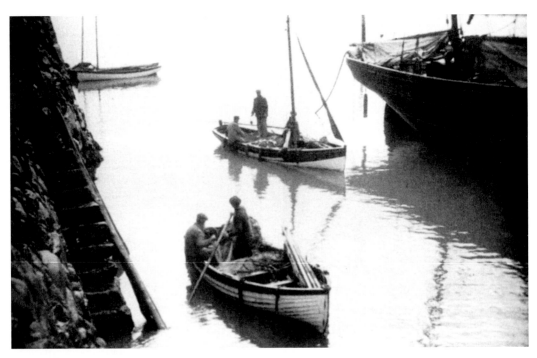

The jetty, c. 1910. Fishing was once a thriving industry: here fish are landed from a large craft in the upper picture and sold in the lower. The bollards for tying up (centre of the bottom photograph) are old cannon sunk into the concrete. Some of these have now been removed and mounted on to carriages to decorate the jetty.

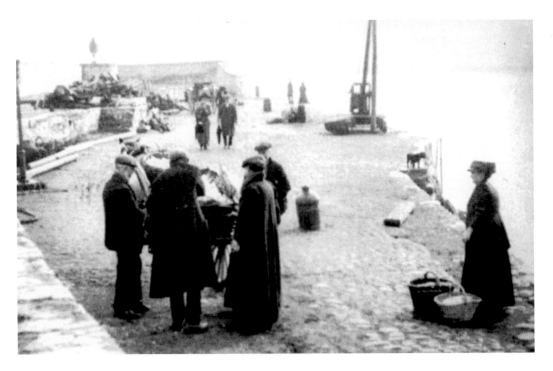

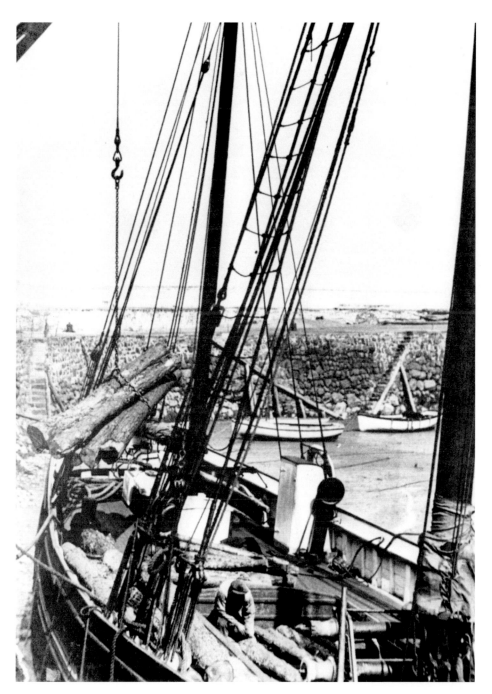

The *Emma Louise* loaded with pit props for South Wales, *c.* 1946. She will return with coal. The *Emma Louise* was our last locally owned boat, a 56 ton ketch. She was owned by Captain Philip Rawle, the harbour master. By 1953 she was worn out and sold. Trade staggered on for a few years, but by 1958 it had stopped altogether.

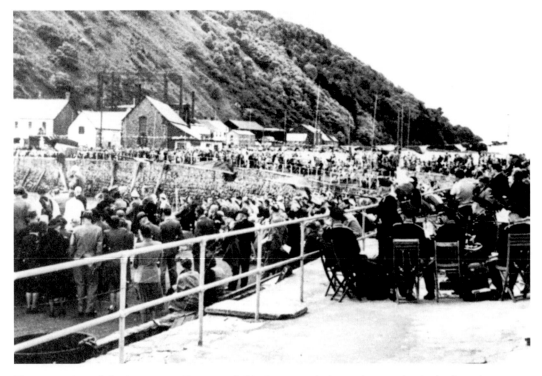

The re-opening of the jetty, 1951. Because of shingle accumulating at its mouth, the harbour been closed. By 1951 this had been cleared and the Urban District Council had assumed responsibility for the harbour. As the pier was never rebuilt the harbour served as the only calling point for the channel steamers.

The jetty with the *Emma Louise* in. The first harbour was a little further to the east opposite what is now Blenheim Road. This one was built in 1616 at a cost of £5,000 and considered a good investment as ships traded from Minehead to as far away as the Mediterranean coasts, although the main trade was along the coast and to Wales and Ireland.

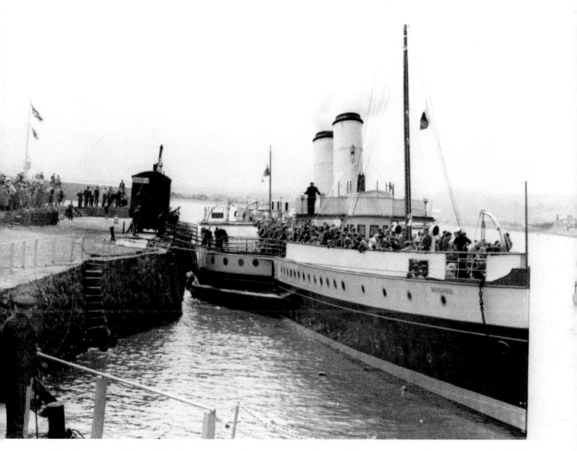

The Jetty 1951. Here is *Britannia* soon after the re-opening. Although many endeavours to rebuild The Pier (page 13) have come to nothing interest in it survives. Meanwhile steamers still call at The Jetty during the summer months.

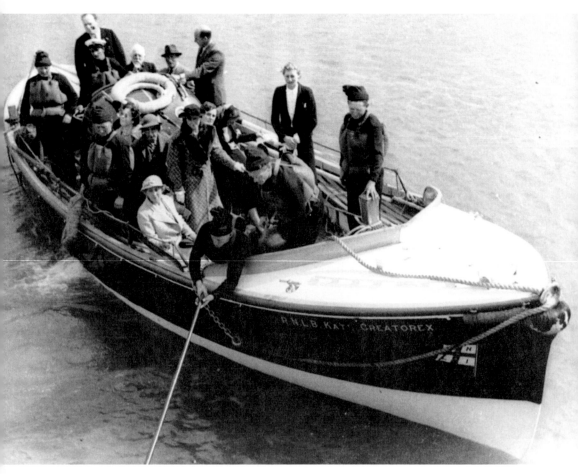

Kate Greatorex, 1939. She was our first motor-driven lifeboat and cost £5,000: the money came from a legacy. She stayed at the station until 1951. During the war she was frequently called out to search for crashed planes but recovered one prize few lifeboats can boast – a barrage balloon.

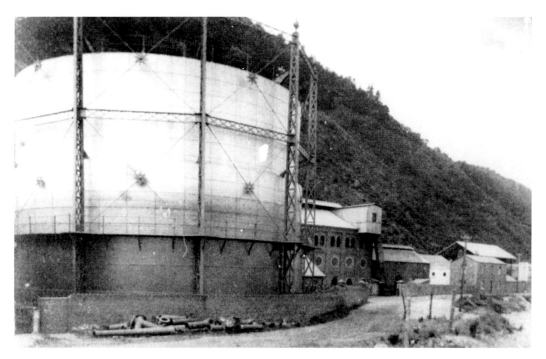

Quay West, 1930. The Gas Light and Coke Company was formed in 1868 and it was not long before retorts, three gasholders and workers' cottages lined the shore. After natural gas ceased production every sign of the enterprise gradually disappeared. New flats have been built over two of the holders while a grassy mound just behind the lifeboat house marks the site of the monster in the foreground.

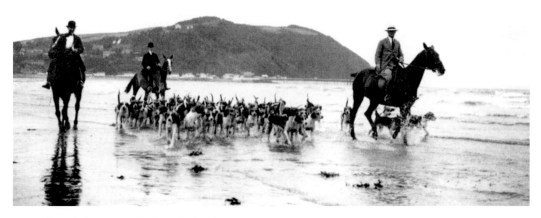

Hounds being exercised on the beach, 1935.

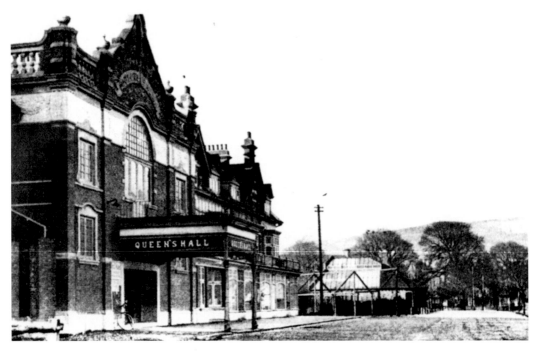

The Queen's Hall, 1914. It opened on 6 June 1914 having been built by local builders. J. B. and S. B. Marley who owned a large brickworks on the site of the present Butlins and at Alcombe. With 750 seats it was the first attempt to bring tourism to this end of the promenade. Further along is what looks like scaffolding: they are actually the supports of a small tented theatre called Arcadia.

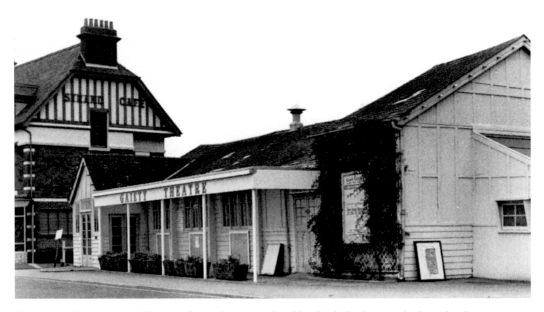

The Gaiety Theatre, 1978. The tented Arcadia was replaced by this little theatre which, under the same name, served us well until the end of the Second World War when the name was changed to the Gaiety. It was demolished in 1979 to make way for the Carousel Amusement Arcade.

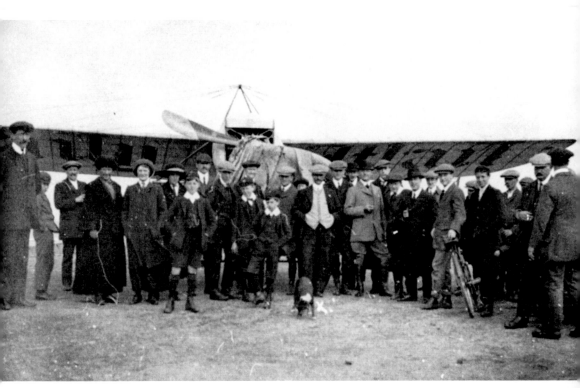

Minehead beach, 1911. Alfred Vowles can be seen in his own 'picture, leaning on his bicycle with one hand extended holding the cotton that releases the shutter. Monsieur M. Salmet was touring England as a *Daily Mail* advertisement (the words 'Daily Mail' are just visible on the underside of the plane's wings) but came to grief near Minehead when he invited the son of a Taunton alderman, Mr Van Tromp, up for a flight and came down in the sea off Watchet. Luckily they only got wet and the plane was towed in later. Vowles photographed the take-off and then heard the news of the crash. He cycled to Watchet in time to get a shot of the rescued couple. The story got out of hand and can still be heard today as 'he took the whole of Minehead council up, they came down in the sea and were never seen again'!

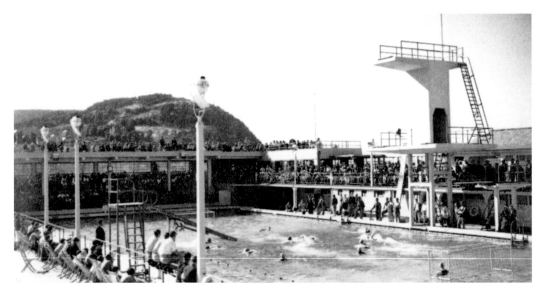

The Lido 1936. Opened that year it boasted heated sea-water, high diving and numerous springboards. It offered galas, water polo and diving demonstrations. Despite part of it becoming a gas contamination centre during the last war it remained open. In the 1960s it was sold to Butlins and finally demolished in 1991. A small village has now been built on the site.

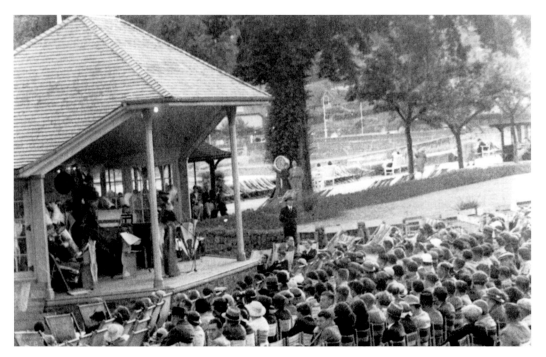

Jubilee Gardens, 1936. This is where large numbers of people sat in the cold and enjoyed performers such as Dorothy Holbrook's Harmony Hussars, Sid Nit's Lancashire Loonies, Scat Singer's Syncopated Swingsters and Evelyn Hardy's Ladies' Band, the latter also playing the newly built Regal Ballroom. Having survived a demolition move it is now a restaurant.

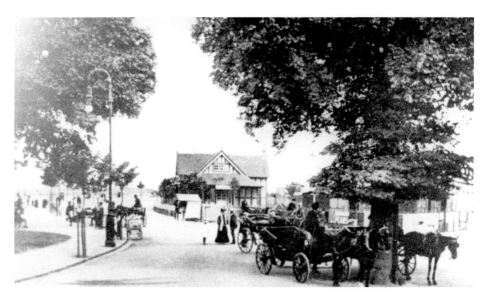

The promenade with the Bungalow Tea Rooms, 1906. In 1935 it was remembered for 'reviving cups of tea and well-cut bread and butter, and any other dainty you can imagine ... it belongs to that period when the English were content to be mildly ornamental and did not despise this Victorian virtue in favour of strong hard lines.' Today it is a shell shop and awaits demolition to be replaced by a public house or an extension to the amusement arcade which is now next door.

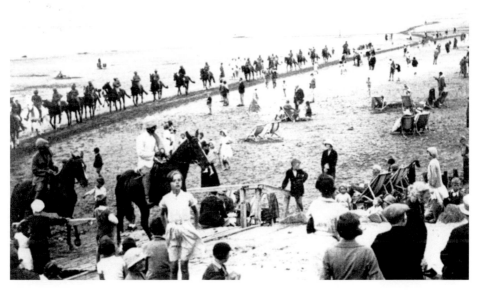

Polo ponies being exercised on the beach, c. 1935. Before the war Dunster was famous for polo but it was in Minehead that the ponies, their owners and trainers were accommodated. Note the warm clothing of the onlookers. Salt water has long been regarded as very good for horses.

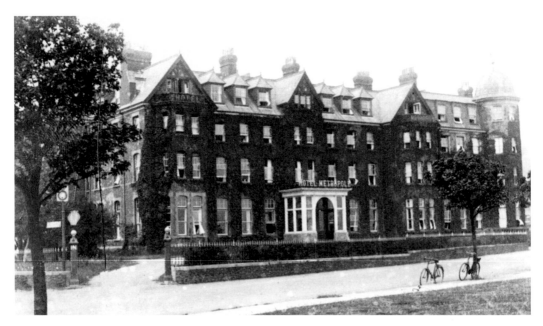

The Hotel Metropole, 1905. The most famous of Minehead's hotels, it was originally built without the dome on the right. It was the height of luxury as the interior picture below shows. Outside it had both tennis and croquet lawns, and large stabling. Two wars changed the habits of holidaymakers and the hotel was split into flats, keeping the left-hand portion as the Hobby Horse Inn with the original hotel ballroom as its function room.

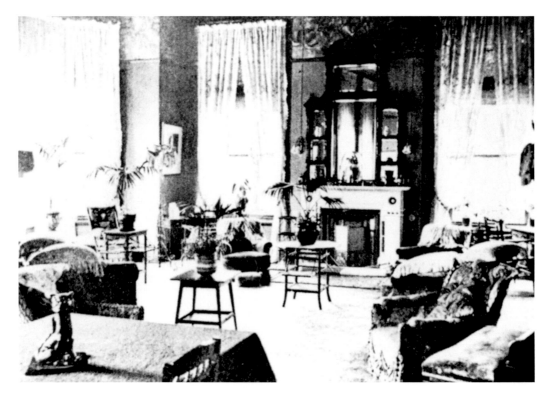

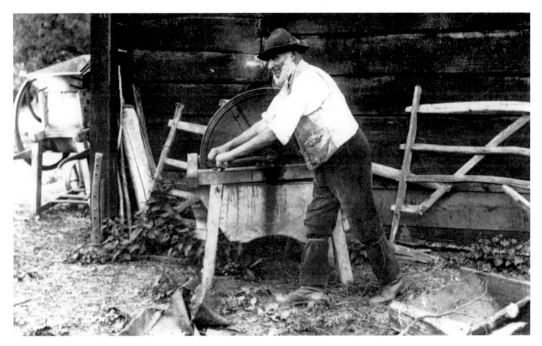

Farm labourer, c. 1907. Alfred Vowles, in his memoirs, describes taking photographs for magazines and I suspect that this one was to illustrate country work for the more sophisticated market.

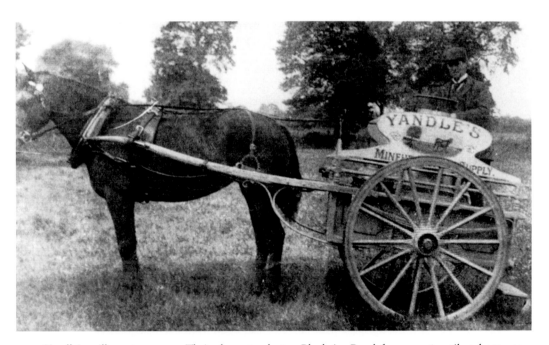

Yandle's milk cart, c. 1910. Their shop stood at 1 Blenheim Road from 1906 until at least 1935. Monique's dress shop now occupies the premises.

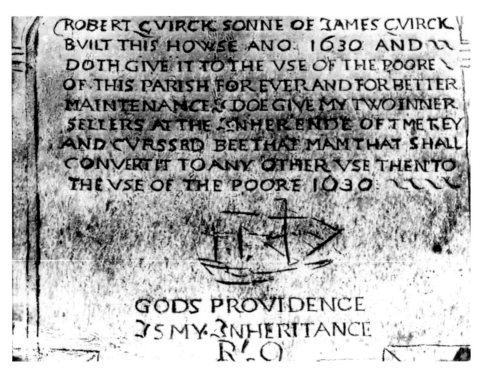

The almshouses plaque, erected 1630.

The Gibraltar cellars on the quay, 1907. When Robert Quirke gave his almshouses (pictured on p. 27) to the poor he also gave his cellars for their upkeep. In 1907 they were converted into a mission and reading rooms. They are now St Peter on the Quay, a tiny but fully working church. The turnstiles of the pier can just be seen in the background.

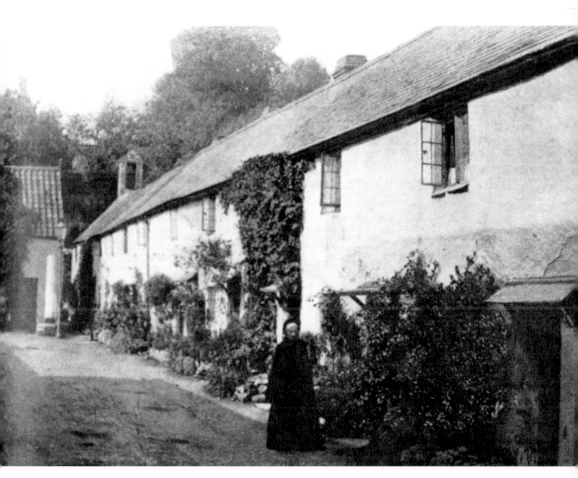

Quirke's almshouses, *c.* 1900. They were built in 1630. According to legend, after Robert Quirke had been caught in a storm at sea, he had bargained with God that, if He would spare him, he would sell the boat and build houses for the poor with the money. He was saved and kept his promise. It is said that the bell that still hangs on the far end of the row is from Quirke's ship. During the 1980s the little houses were extensively renovated and, although they now cannot shelter as many people, their standard of comfort has been greatly improved without altering their frontage.

Tythings Court, 1908. Until quite recently it had been presumed that a tithe barn had stood somewhere in the vicinity, but, when one of the cottages here was being renovated, *c.* 1985, the huge round columns of the barn were clearly seen in the house. They are still just visible under the plaster.

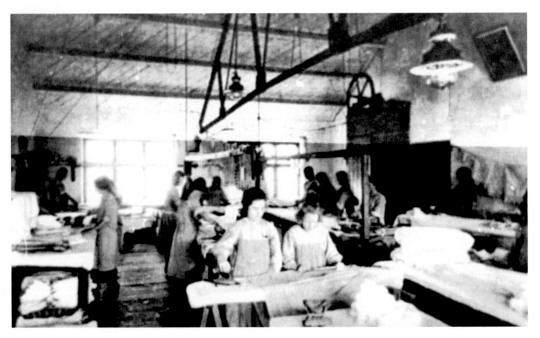

The convent laundry, 1930s. The Convent of St Louis, which owned St Teresa's School, also had an orphanage that supported itself by this laundry. The orphans could be seen on the streets of Minehead pushing the big wicker laundry carts which collected and delivered to the houses and hotels.

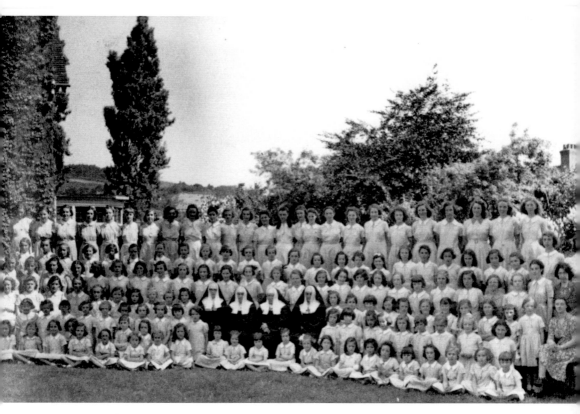

St Teresa's School, 1941. St Teresa's School for the Daughters of Gentlemen was opened in 1926 when the old Blair Lodge was rebuilt after a fire. The grounds at the back adjoined the beautiful convent gardens which grew the most wonderful peaches on its high brick walls. Many of the children in this picture had hurried away from war-torn Europe having no idea of the fate of their parents. The author stands just behind the last nun on the left.

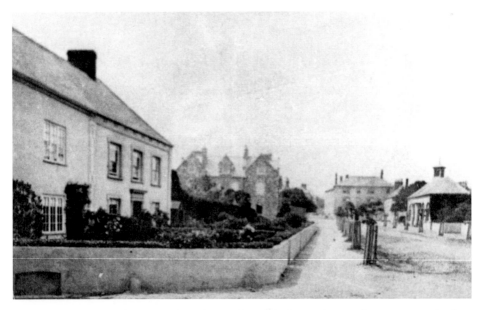

The Parade, 1875. The houses on the left were demolished to make way for Henry Wood's shop (see opposite): today the site of W. H. Smiths. The Market House on the other side of the road was demolished in 1902. The only building remaining today is the house on the far left, then a bank but now Chanin and Thomas's offices.

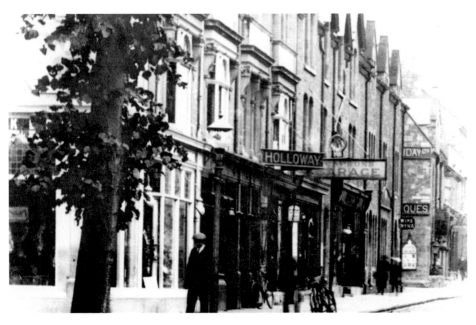

The same scene, 1907. A totally new block of shops has been built. Capron's garage can be seen slightly right of centre in the picture but as yet lacks the petrol pumps which used to swing out over the road to fill cars waiting at the kerb. On the corner of Bancks Street is Haywards Bars and Mineral Water Manufactory. All these buildings survive but with different trades.

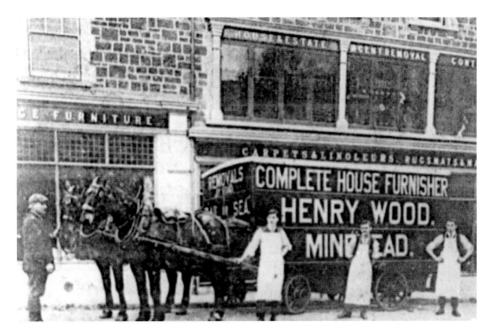

Henry Wood's shop stood on this site for about seventy-five years, selling brass bedsteads, jugs, basins and linoleum in addition to the removal service. They had vast storage areas in the old stables in Alexandra and Irnham Roads and a second-hand shop in the redundant Cosy cinema in Bancks Street.

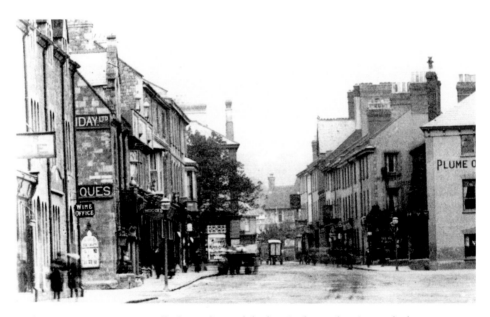

Park Street, 1926. Moving traffic leaves lines of shadow in the road owing to the long exposure. Once a street of private houses, in 1926 (just before this picture was taken) a new post office was built, which can be seen at the top of the road. Now that it led somewhere the houses quickly had shop fronts inserted. That post office has now closed and the effect on Park Street is marked.

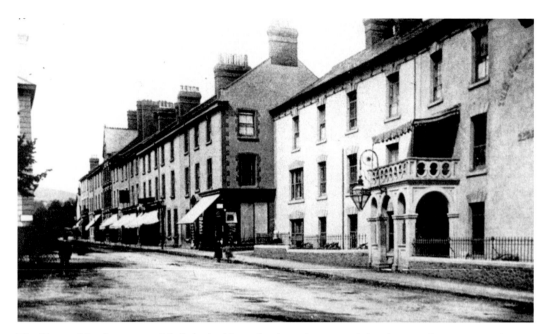

The Plume of Feathers 1928. Of all the buildings that have disappeared the Plume is the most missed. It stood on the corner of Park Street and Holloway making a commanding position at the top of The Parade. It was a coaching inn with yard and stabling. To it came coaches for Lynmouth, Bridgwater and Taunton, and in it were held the election dinners of our rotten borough days. Strangely no-one knows the day that it was built. At the end of its life the ground floor was below street level and flooded badly. I have seen tables and chairs floating in the dining room.

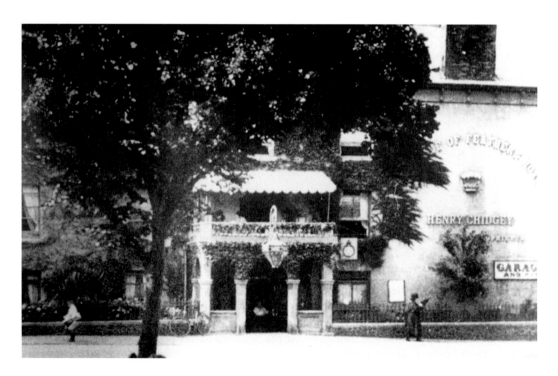

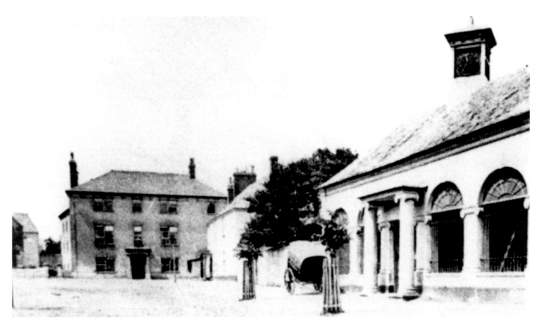

Looking towards Park Street, before 1901. The old Plume of Feathers is in the middle. The Market House (see also p. 30, top) on the right with the clock was demolished in 1902 to make way for the two-storey Market House now on the site.

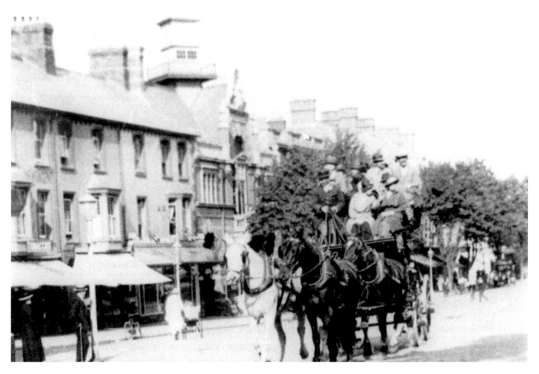

One of the last regular horse-drawn coaches to come into Minehead. Unfortunately, because of the long exposure needed, there is a slight blur on the photograph.

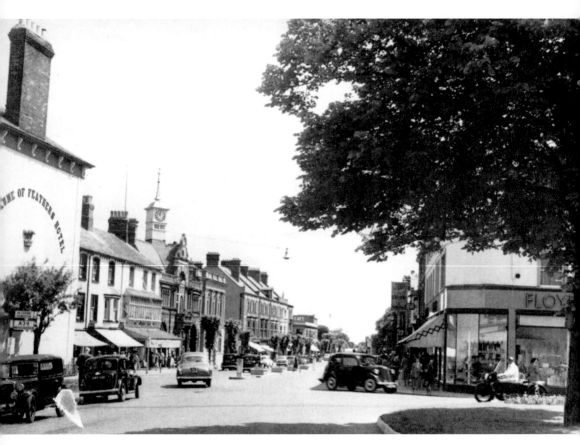

The Parade, 1947. Today the name Floyds Corner and a flat-iron shaped building are all that is left of a legend. Mr Isaac Floyd opened his first shop in Friday Street, the Ready Money Drapers, just to the right of this picture, in 1877. In addition he carried his goods by pony and trap to the neighbouring villages. In 1900 he acquired the corner shop shown here from Mr Bond the chemist and draper. In 1910 other shops each side had been purchased and members of his family had joined him in the business. Isaac died in 1937 but the business continued to expand and, by 1961, had the additional space to become a 'walk round store'. In 1979 the shop was sold to Bealsons of Bournemouth who were there but a couple of years before the premises were broken up into a series of small shops again. In the background on the left is the canopy of Boddy's restaurant, the British Restaurant during the war, which was later sold to Boots the Chemist whose small shop can just be seen on the right-hand side. The air-raid shelters which stood in the middle of the road have been replaced by flowers but, on the roof of the Market House, the air-raid siren can still be seen.

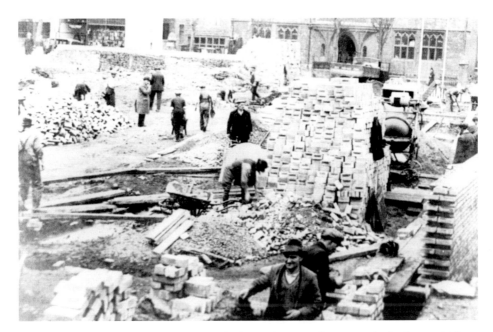

The building of the Regal Cinema, 1933. The hospital can just be seen in the background. Not a single man is without a hat but there are certainly no protective ones.

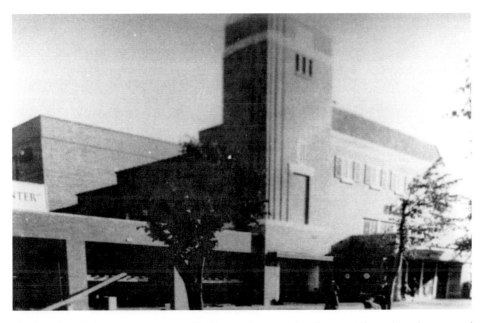

The Regal just before opening, 1934. The Regal Cinema and Ballroom still stands in the centre of the town. It is now a listed building. It cost £12,000 to build and was opened by actor Clifford Mollison. It occupied the site of an old tannery and, although the design was utterly out of place in the little Victorian town, no-one complained. A newsreel film of the opening ceremony is still in the possession of the owner.

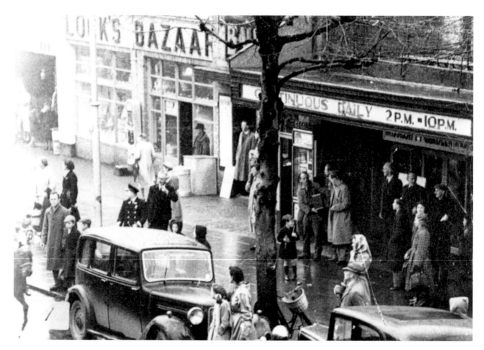

The Regal Cinema and Lock's Bazaar, *c.* 1939. Lock's Bazaar was a local imitation of Woolworths although the real thing stood on the other side of the Regal. Next to the Bazaar is the Olympia, an amusement arcade which has been there since the cinema's opening in 1934. Lock's was turned into a car showroom many years ago. The ballroom, whose entrance can just be seen next to the cinema, is now a shop.

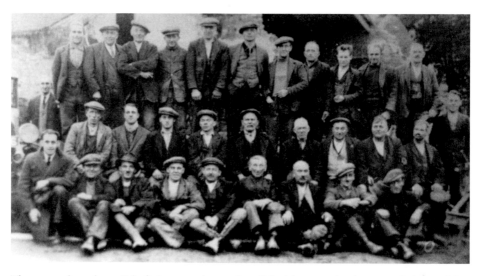

The tanyard workers. Siderfin's tanyard was demolished in 1934 having occupied a position between Summerland Avenue, Summerland Road and The Avenue for many years. The hooter which used to summon the men to work also announced any special occasion and proclaimed victory in the First World War.

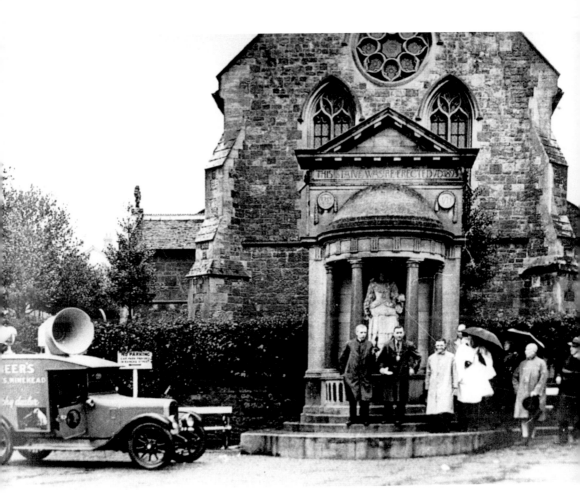

The proclamation of King George VI, 1936. Here, beneath the statue of Queen Anne in Wellington Square, stand the chairman of the Urban District Council and the vicar doing their civic duty in the pouring rain to a small audience. I think the chairman is wearing the new jewel of office presented to the town by two anonymous donors on 14 September 1936. The statue of Queen Anne had been a somewhat embarrassing gift to the town in 1719 by its then MP Sir Jacob Bancks. She was first housed in St Michael's Church, but spent time in a cellar and on the jetty before being re-erected here in 1894.

The Old Priory 1906. Standing on the corner of Summerland Road and The Avenue no-one knows how old it is or for what it was originally built. It spent many years as the Dunster Castle Estate Office, became a sweet shop, fruit shop and flower shop. Each different owner has altered it but, if you stand back a little the upper portions are still recognisable.

Warren House, date unknown. This house stands way out on the golf links at the eastern end of the seafront. It is of great historical value with a cruck roof that draws the attention of experts. From the look-out you can scan the bay to look for approaching herring shoals. It is widely believed that the Minehead outrage of *Lorna Doone* took place here but, although Blackmore says 'This vile deed was done beyond all doubt', nothing about it can be found in the town's archives.

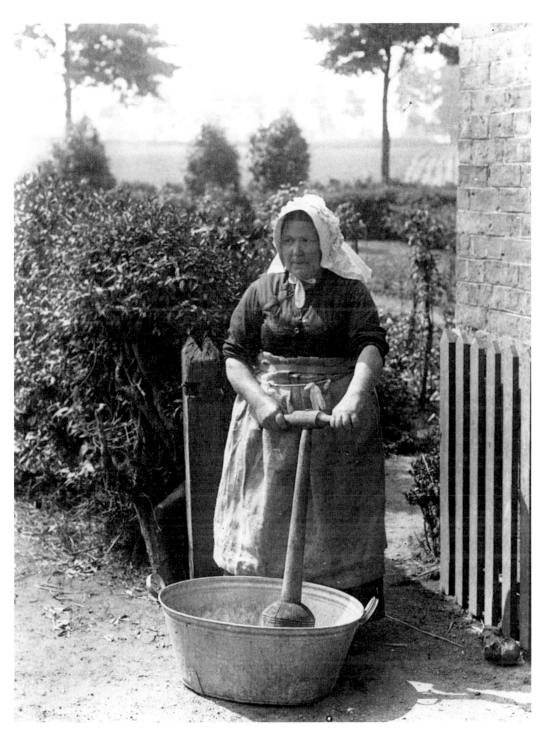

Washerwoman using washing dolly, c. 1906. The washing dolly was like a three-legged stool with a long handle in the middle. You placed it in the tub of washing and turned it to and fro like the paddle of a present-day washing machine. The washerwoman's bonnet with the large frill extending over her shoulders illustrates a prevalent fear of the period of letting the sun get on the back of the neck.

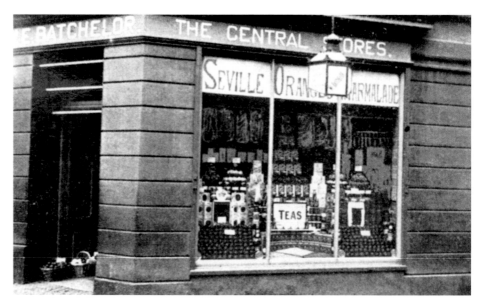

Batchelor's Stores on the corner of Holloway and The Parade, *c.* 1906. In that year Walter Batchelor founded one of the most popular of the town's grocery stores.

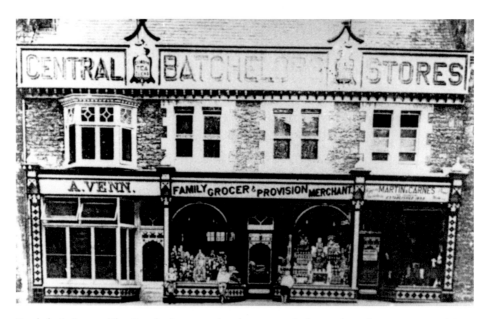

Batchelor's Stores, The Parade. In 1910 the shop crossed the road to these more prestigious premises where it remained until well after the Second World War. It was the kind of shop where the customer sat in front of the counter and the assistant brought the goods asked for, then totted up the bill on the side of the sugar packet. The premises are now occupied by the Alliance and Leicester Building Society. Albert Venn the butcher had also moved from Holloway Street at the same time but by 1920 he had closed. Martins and Carnes, the bootmakers on the other side, had no better luck.

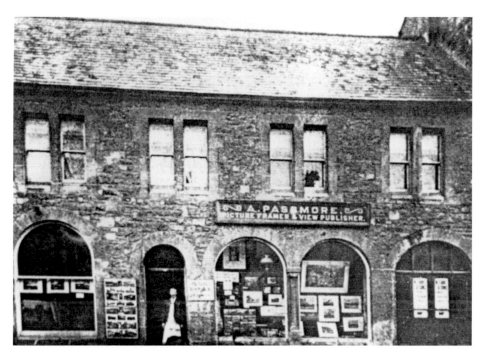

The same shop, before 1910. Before Walter Batchelor moved into his new premises in The Parade they had been occupied by Harry Passmore selling pictures, frames and fancy goods.

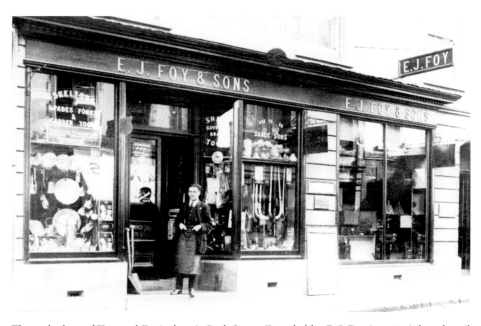

The early days of Tarr and Foy's shop in Park Street. Founded by E. J. Foy in 1989 it lasted until 2006. In 1985 the shop donated all its early account books to the Somerset Record Office.

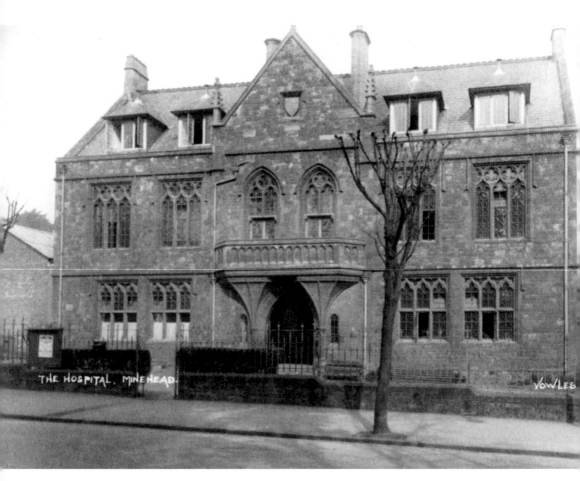

The hospital, 1922. The hospital was built in 1888 on the main road, opposite where the cinema stands today and, when built, opposite the tannery. Such a noisy choice seems strange but it was originally designed as a town hall with a concert hall on the first floor seating two hundred. In 1894 Minehead had a new Urban District Council which no doubt felt that this imposing building was fully warranted. When war came, in 1914, the wounded were brought to Minehead and the building was taken over as a Voluntary Aid Detachment (VAD) hospital. It never reverted to its original use and eventually replaced the town's by now outgrown hospital at Dunster. Apart from the four dormer windows let into the roof it was hardly changed on the outside and little has changed in the façade to this day.

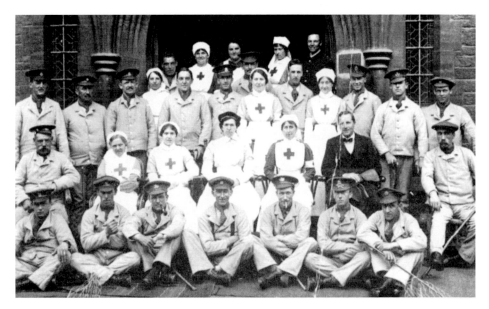

The hospital in the First World War. The photograph depicts the wounded with Matron Webber (in the dark hat). One presumes they are in 'hospital blue' but the tied scarves over collarless shirts seem unusual.

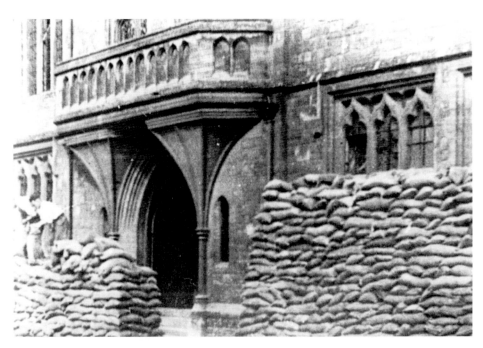

The hospital, 1939. War came again and, although no bombs fell on Minehead, we had to be prepared. Sand bags protected our strategic properties and blast walls were built outside the almshouses. Opposite them and in the middle of Wellington Square static water tanks were constructed.

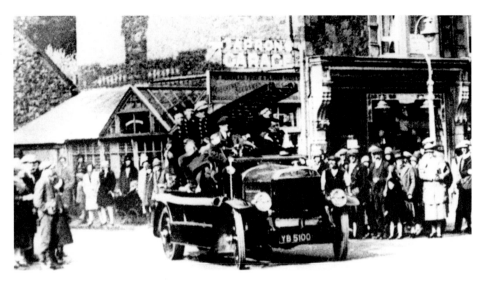

The fire-engine swinging out of Market House Lane. The original horse-drawn machines had been kept in this narrow lane, with the horses stabled in the Plume of Feathers yard. Then the right-angled turn out of the fire station was relatively easy to accomplish. With the advent of motorized appliances it became more difficult, and as they got bigger, impossible; a new fire station had to be built in Townsend Road. On the night of 24 November 1940 the engine was called to Bristol to assist during the blitz but, with blacked-out headlamps and no street lights, it was involved in an accident before it arrived, killing one fireman; a tragic end to a brave turnout.

Bampton Street before 1914. It had been decided to join this to Friday Street. Here they are about to break through into Bampton Street. You can see the new paving already laid in the foreground. Thus Quirke Street was formed.

Bampton Street, one of Minehead's oldest streets. One episode in its history started just past the big house on the right on 10 July 1791, according to the *Sherborne Mercury*. 'Yesterday was the most unfortunate day ever to be remembered in this town. Mr May a considerable miller who lived in Bampton Street yesterday noon had occasion for some pitch or tar which was in a barrel near his back door and, with a hot iron, he meant to take some out, but it unfortunately caught flame, he rolled it into a small stream of water near at hand, when it blazed much more. Near the spot stood a wallet rick of immense size to which it communicated there to the adjoining houses on the side of the street.' In all seventy uninsured houses were destroyed, the town's fire-engines were found to be useless and 400 people were made homeless. Collections were made in parish churches all over England and money poured in from many other places to provide a rich source of argument and slander for years to come.

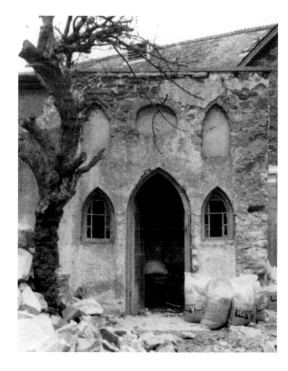

During recent (1993) renovations to Bampton House this was discovered in the garden. Bampton House joins the Old Dye House which, in 1811, housed some of the first Methodist meetings, it being then the home of Isabella Binding. Demolition was halted but as yet we have no firm evidence that there is any connection between this building and local Methodist history.

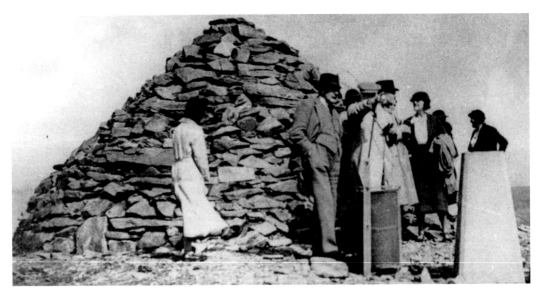

First meeting of West Somerset Archaeological Society, 1938. Alfred Vowles was a founder member and secretary. For their first meeting they climbed Dunkery to see how many counties they could see. Unfortunately a fine mist and drizzle came down and Somerset itself could scarcely be seen! Nevertheless they came to the conclusion that fifteen counties were visible, made up of ten definite and five doubtful. Soon they turned their attention to Burgundy Chapel (below, 1941) which lies on the coast between Minehead and Porlock. It had fallen into decay and little streams had built up the earth to cover its doors and windows. Vowles led the party that uncovered large portions of the building but work had to be suspended during the war. When the society returned in 1982 much had to be done again but, since then, working parties have been keeping it clear. While we know that a service was conducted there in 1120 we have very little evidence of its real purpose.

The Hobby Horse in The Parade, *c.* 1907. Every Mayday and for the following three days the horse dances through the town to the accompaniment of drums and melodeon culminating in the 'bootee' at Hopcott. This ceremony involves taking a victim by the arms and legs and touching him or her three times on the ground. The repetitive tune played is, according to Cecil Sharpe the great folksong collector, *The Soldier's Joy* or *The Boat is Tipping Over*, which are remarkably similar.

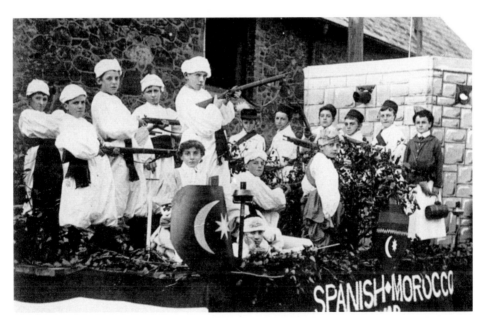

Minehead Carnival, 1911. Spain occupied the north coast of Morocco in this year. The children seem to be holding real guns while the young nurse has a cask of brandy ready for an emergency.

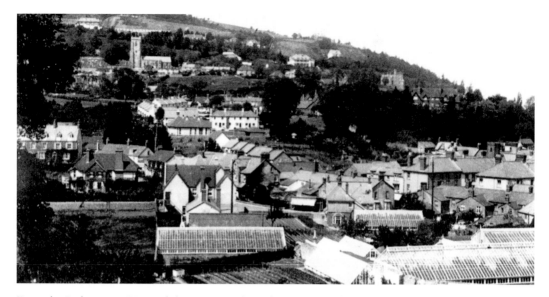

From the Parks, 1920. No work has yet started on the new post office. The greenhouses belonged to Webber's Nursery which had a shop near to where the post office now stands. In the distance Watery Lane School is new and the right side of Church Street is entirely undeveloped. Fred Page had the tiny corner shop near the Baptist Church.

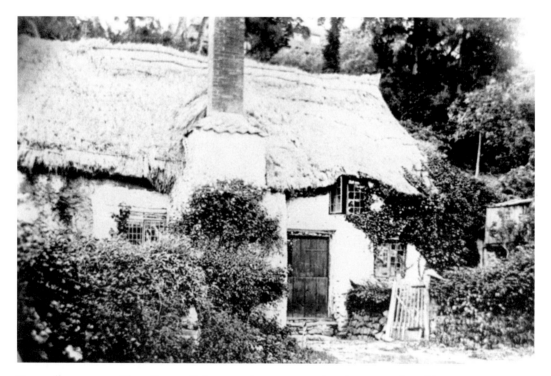

Pemswell, pre-1910. The village still has stepping stones and walnut trees, but this cottage was condemned in 1910 and demolished. A hotel was later built on the site, and is now occupied as a private house.

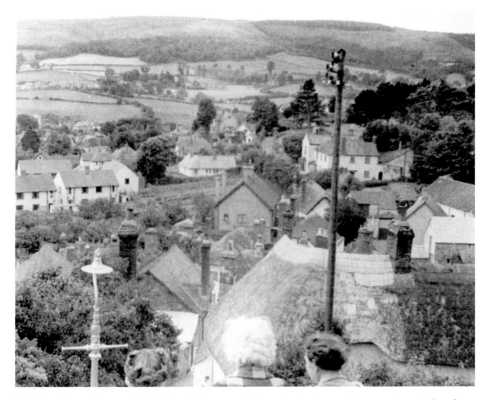

Minehead from the top of the Church Steps, 1946. In 1980 the lower photograph was taken from the same spot. An enormous amount of development has taken place in the background and great bungalow estates cover Park House Farm and its fields.

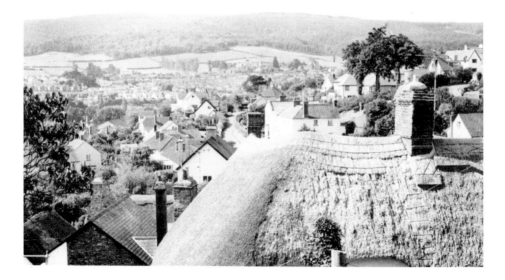

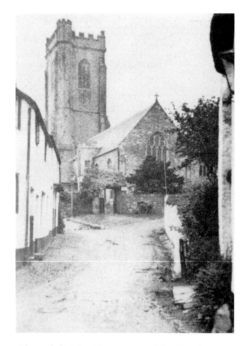

Above left: The Cross, 1903. The first houses on the left were once cider houses and barns but were converted to dwellings in around 1880. The area's name derives from the meeting of the roads from town and quay.

Above right: The Jack Hammer sits behind the church screen to this day, having survived restorations, lightning and misuse.

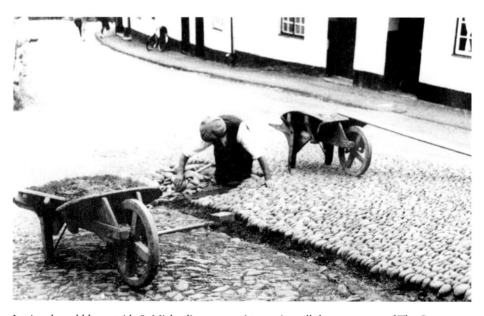

Laying the cobbles outside St Michael's, *c.* 1930. At one time all the pavements of The Cross were laid with them as well.

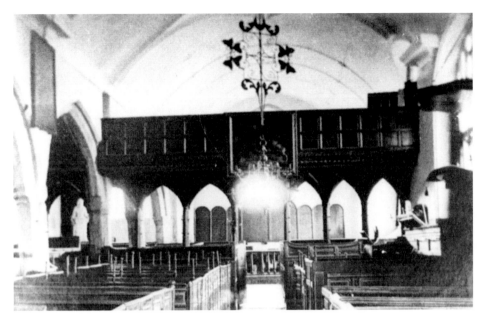

St Michael's Church before the restoration of 1886. Note the gallery and the paucity of the now beautiful rood screen, pieces of which were later found around the town and put back in original positions. In the left corner can be seen the statue of Queen Anne now in Wellington Square (see p. 37).

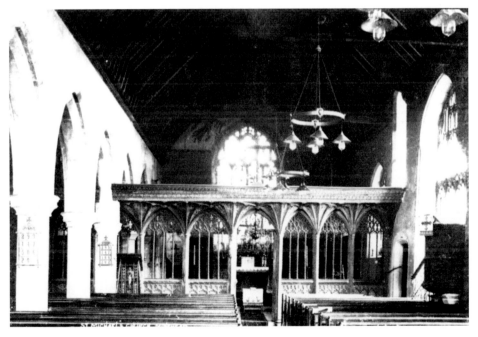

St Michael's, *c.* 1910. The gallery is gone, as is Queen Anne, and the roof is changed out of recognition, but the rood screen is restored to its original beauty.

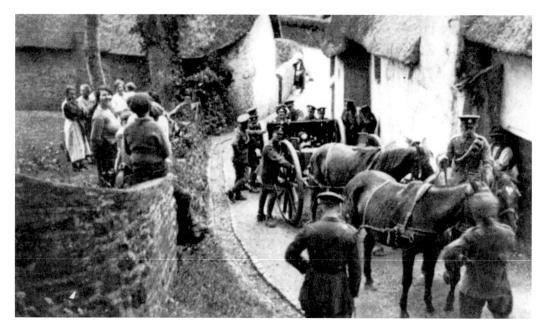

The Camp Ground, *c.* 1914. Above Minehead is the Camp Ground, used for military camps and exercises. Here the army is trying to persuade mules to pull the gun carriages up Moor Road. During the First World War hundreds of mules were brought to the town by train to recuperate from the horrors of the trenches.

Parkhouse Road, 1930. The road is so called because of the large farm of that name that borders it on the right. Development had just started at this time; the whole of the area is now covered with housing.

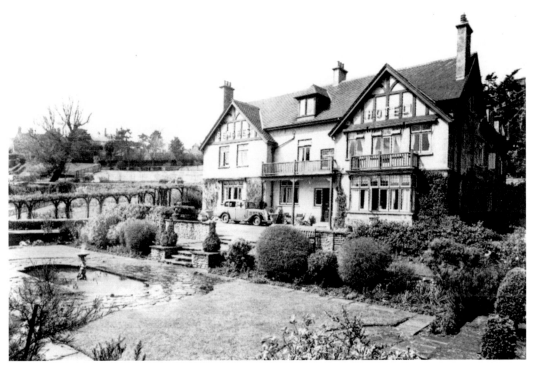

The Benares Hotel, Northfield Road. Founded in 1932 by the Cornish family it was given the name Benares in memory of The Benares Food Reform House in Brighton which was started by the family. The building remained a hotel until 2001 when it was demolished in favour of luxury apartments.

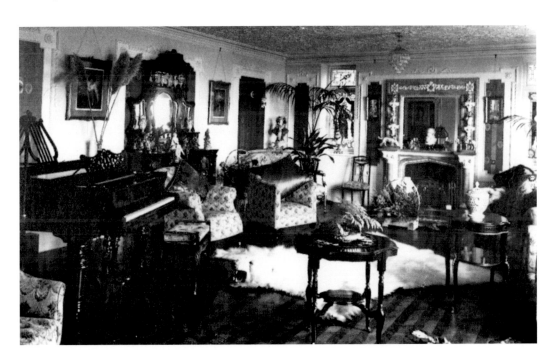

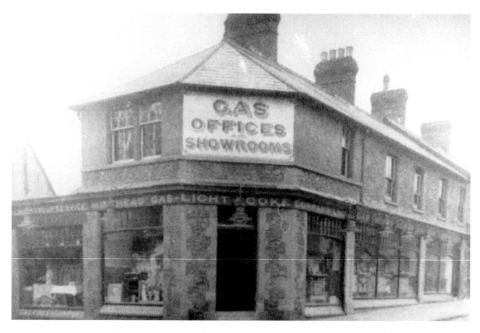

Gas lighting came to Summerland Road on 25th June 1901. The road would be 'lit whether it be moonlight or not' stated the Gas Light and Coke Company's minutes. The premises are now used as offices by the West Somerset Council.

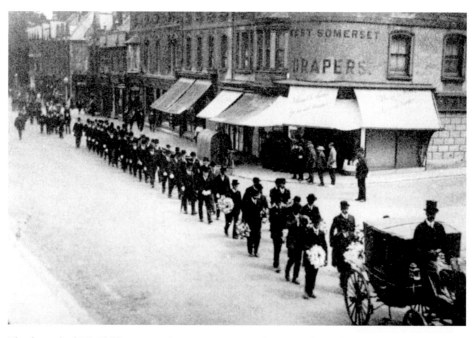

The funeral of Mr Phillips, 1911. His cortège passes the expanding Floyds shop with the blinds respectfully pulled. This photograph was taken from the upper storey of the Plume of Feathers.

North Road, *c.* 1910. Tucked behind The Avenue, North Road will attract no-one for its beauty. Here Thomas Kent Ridler ran his business in timber, lime, slate, coal and salt. He also had premises on the quay and in Porlock. Still known to many as Ridler's Yard it now houses the St John's Ambulance Brigade hall.

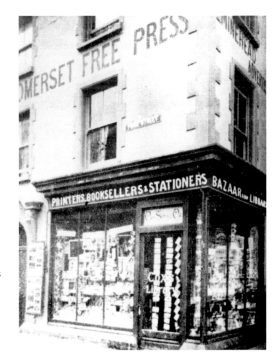

The *West Somerset Free Press* shop, 1880s. Minehead's local paper since July 1860, it was published and printed in Williton. The paper was owned by Cox and Company and this is their Minehead shop in Park Street next to the Plume of Feathers. It remains a newspaper shop today.

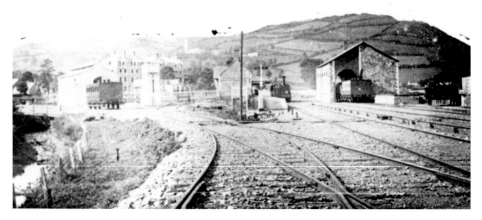

Station approaches, pre-1882. The railway came to Minehead on 16 July 1874 with its station on the seafront. This picture shows the entrance to the station in broad gauge: it was converted in 1882. In the background the Esplanade Flats are nearly finished but building has not yet started on North Hill. The line was closed on 4 January 1971, a victim of the 'Beeching axe'. It has been re-opened by the West Somerset Railway as a mainly steam service between Bishops Lydeard (one station from Taunton) and Minehead, and it is always hoped that one day it may be reunited with the main line.

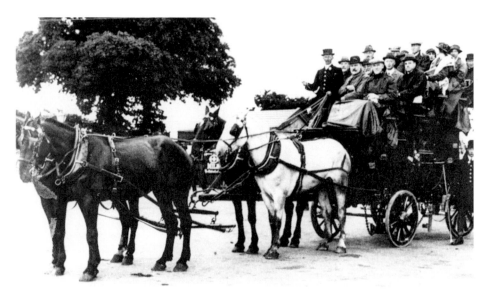

The Lynmouth coach starting from the station, c. 1911. With this load it had to climb Porlock Hill and descend Countisbury, doubtless with more than a little help from passengers and extra horses (see p. 84).

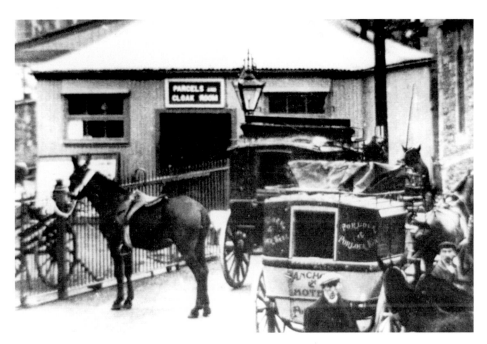

The station gradually became important for people visiting the outlying villages and hotels sent their carriages to meet guests. Here is one from the Anchor Hotel, Porlock.

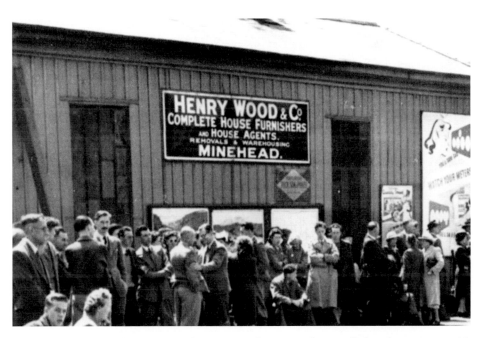

Passengers waiting in the station yard, c. 1947. In later years buses called at the station to pick up passengers for the outlying villages. Compare the advertisement on the wall with the upper photograph on p. 31.

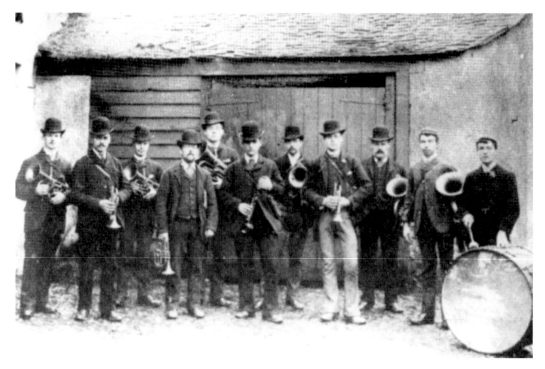

Minehead town band, pre-1900. Note the clarinet player in an otherwise all brass ensemble.

Development spreads out into The Parks area favouring the larger type of house designed by local architect Edward Donatti, 1925. The Georgian-style houses in The Parks are still the only ones in the road. All this land is now built on.

Bratton, *c.* 1907. The forge is still there but quite unrecognisable. Looking for it, though, will bring you in touch with this tiny hamlet of great historical wealth on the outskirts of the town.

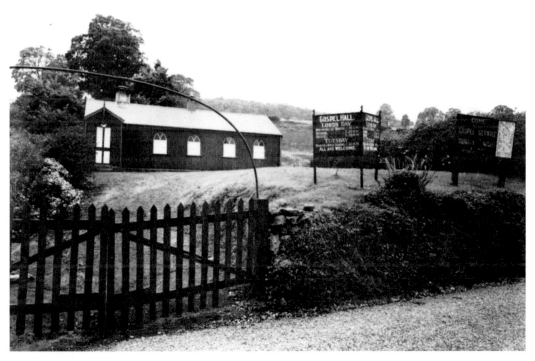

Alcombe, *c.* 1930. Once a separate village it is now joined to Minehead. This little gospel hall, on the main road to Porlock, is now modern and brick built.

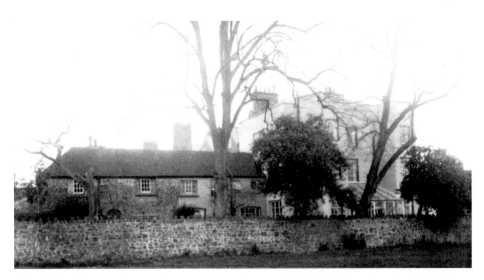

Bircham Road, Alcombe. Beneath this late eighteenth-century house lies a secret of the greatness it once hoped to achieve. When Minehead was laid waste by fire in 1791 it was planned to rebuild the town here, properly planned instead of the usual hotchpotch of thatch and cob that had been lost. They made a start on it with this row of houses, under the first of which was buried a time capsule which contained the plans, newspapers and things expected to interest those who found it. The brave new town of Alcombe, for that is how it was described, got no further and, as far as I know, the box has never been found.

Grove Place, Alcombe, c. 1938. This tiny community of cottages on two sides of a square with gardens in the middle is reached via a small gateway in a wall and two flights of stairs. The church, built in 1861, started life as an independent chapel but, by 1892, was rented as a chapel of ease until the larger church of St Michael the Archangel was built in 1903. It remains a church today, now for the Christian Spiritualists.

The Britannia Inn, Alcombe, *c.* 1915. Today the premises have absorbed two adjacent properties.

The Britannia Inn, Alcombe, 1931. Alfred Vowles took this photograph for the inn's brochure, which contained a doggerel verse eulogising its clean warm beds and rustic comfort.

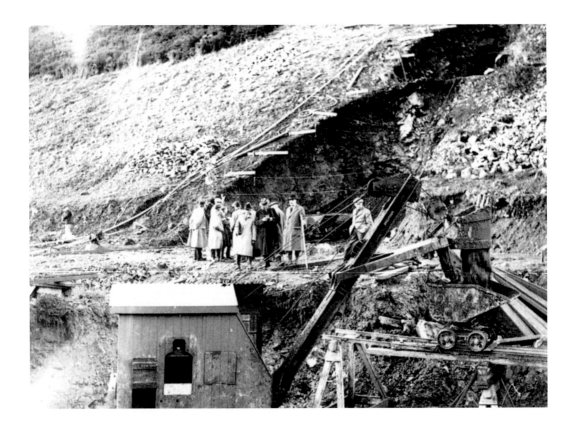

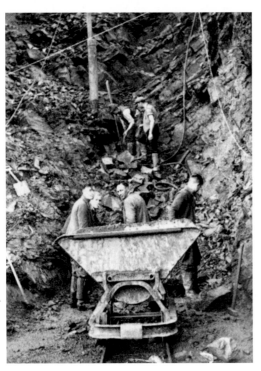

Nutscale reservoir, December 1938. Alfred Vowles published an appreciation of Nutscale, talked about since the twenties and built in the thirties, in which he says: 'During the long history of Minehead, there has been no subject concerned with the town's affairs that has aroused such persistent controversy as this Nutscale project, not one that has caused the spilling of so much scalding water. That the scheme is the best solution to existing difficulties is the belief of many of the ratepayers, while many others are convinced that a much less costly undertaking, and one just as satisfactory, could have been devised close to the town.' But it was built and, apart from a well-founded fear that it might guide enemy bombers to the district when the moon shone on it, has served the town well. The photograph above shows the visit by members of the Urban District Council, while the one below depicts construction work.

two

Dunster

Luttrell Arms Hotel, Dunster.

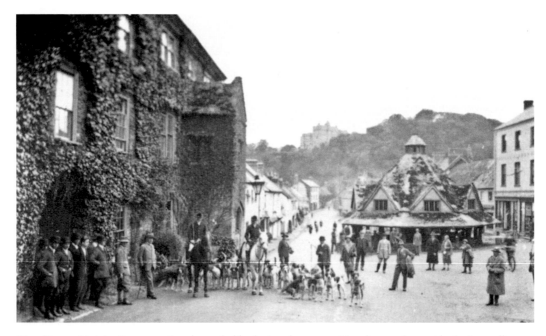

King George V visits Dunster privately, probably during the 1920s. Here he stands outside the Luttrell Arms taking little interest in the hounds brought for his inspection. There are very few onlookers and a remarkable absence of policemen.

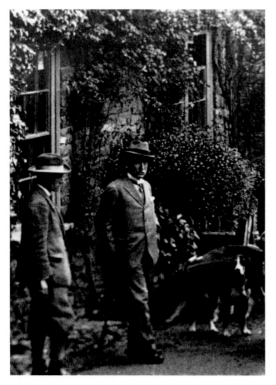

A close-up of the king from the picture above.

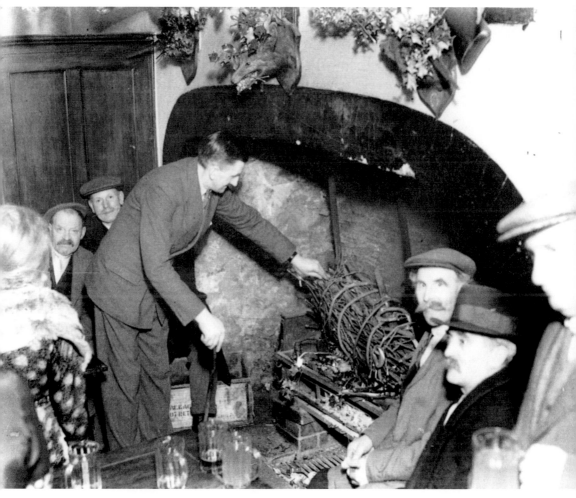

The burning of the Ashen Faggot, Luttrell Arms, 1936. The ceremony took place all over Somerset on Christmas Eve. The faggot is placed on the fire and, as each bind burns and breaks, a toast is drunk. Some faggots were up to seven feet long and three feet in diameter.

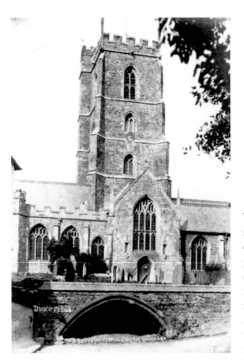

The church of St George, *c.* 1930. If you do not see the church during a visit to the village you will certainly hear it, for it has a peal of eight bells which play tunes every four hours, different for every day of the week. The one for Monday is, rather incongruously, *Drink to Me Only*. It was in Dunster that Mrs Alexander wrote the hymn *All Things Bright and Beautiful*. The little niche in the outside wall is supposed to have housed the stocks but there is little to substantiate the theory historically.

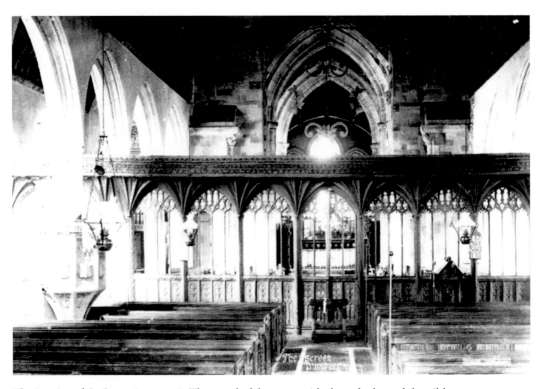

The interior of St George's, *c.* 1908. The wonderful screen, with the soft glow of the oil lamps, must have given a magical quality to evensong.

Beneath Dunster Ball, *c.* 1910. On the far outskirts of the village overlooked by Dunster Ball still stands this row of cottages. They can only be reached by way of a packhorse bridge for pedestrians and a ford over a fast flowing river for vehicles.

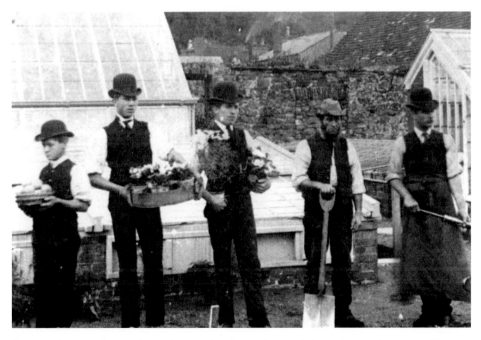

Dunster Castle and grounds are famous for the quality of their gardens and produce. They are remarkably sheltered; even lemons grow outdoors here. The estate workers posing to show off their work look somewhat awkward in front of the camera.

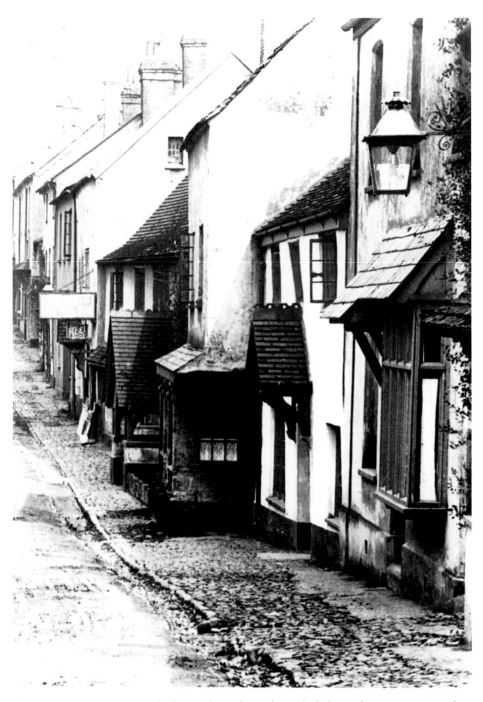

Dunster's main street, 1910. The houses have changed very little but today every one is a shop or restaurant.

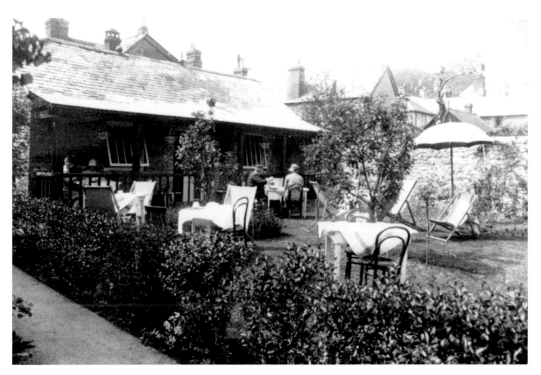

Lock's Tea Rooms, 1928. Through the shop from the main road dainty teas with white bread and butter and Fuller's cakes were served for 1s 6d. The building still bears the same name but has been very much altered.

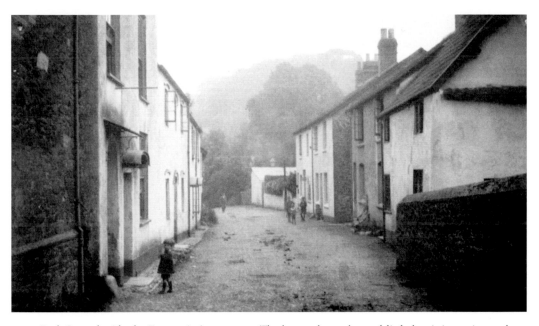

Park Street beside the Forester's Arms, 1905. The houses have changed little but it is tourists and not the village children in the street today.

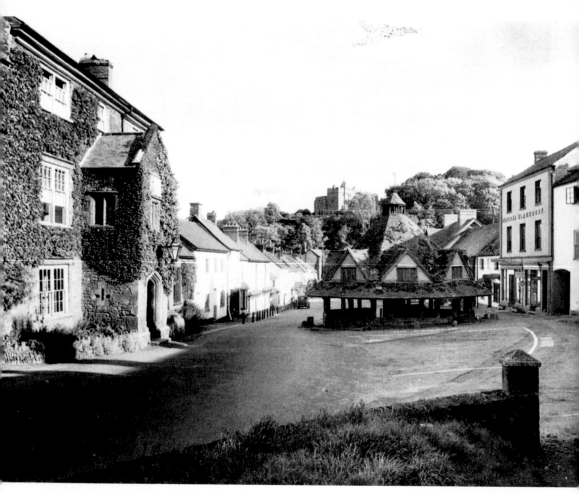

Dunster's main street and yarn market, *c.* 1947. This is a town of landmarks and the yarn market, which was erected by George Luttrell in 1609, can be absent from few pictures. As its name suggests this is where yarn was bought and sold, for Dunster was once famous for its cloth. Nowadays the street is never as quiet as it is here, for this engaging village has almost turned itself into a living museum to accommodate the thousands of tourists that pour in by coach and car. It has many restaurants and shops but none that sell groceries, vegetables, furniture or ironmongery.

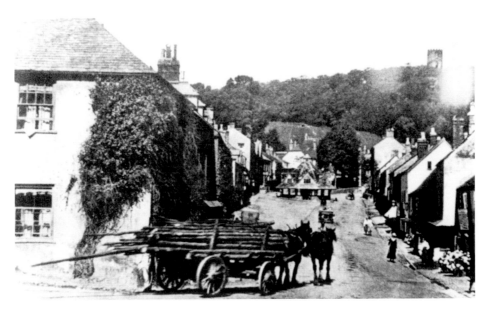

The logs roll round the corner where today stand traffic lights and the pedestrian is in mortal danger if he or she stops to look into the windows of the corner house, now The Cage gift shop. In the far distance, on top of the hill, stands Conygar Tower, a folly built to enhance the hill in 1775. This picture dates from *c.* 1906, and the one below from 1910.

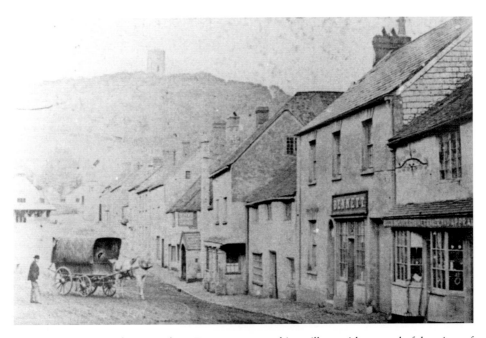

The two pictures on this page show Dunster as a working village with a wonderful variety of houses opening on to the main street. The cobbles are still there but iron railings beside the kerbs protect the walker from the traffic that rumbles incessantly through.

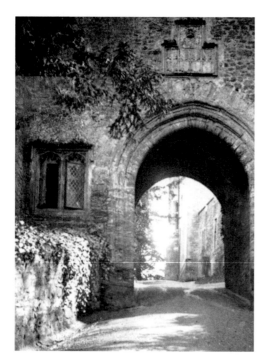
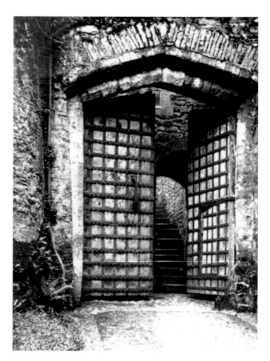

The main gateway to Dunster Castle, which was built in 1617 on the site of a Norman castle. It was besieged for 160 days during the Civil War in 1646. In 1650 300 men were sent by the Council of State – the 'parliament' of the interregnum – to destroy it. The residential portion was untouched but much of the keep and walls were knocked down.

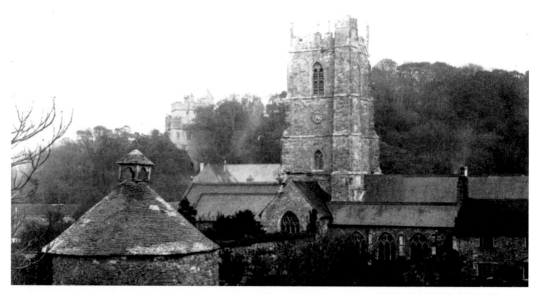

Dovecote, church and castle. A walk round the back of the village proves rewarding: here is the dovecote, with the castle just showing in the distance. The dovecote dates from the thirteenth century, and still contains the revolving wooden ladder for access to the 500 nesting holes built into the thick walls.

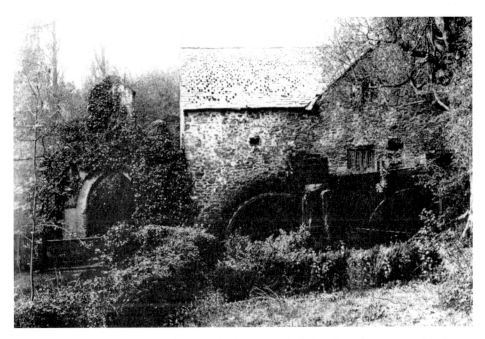

The old mill, *c.* 1930. In the castle grounds, the present building dates from 1801 when it was rebuilt on the site of an older mill. It was used originally to grind cattle food. Restored now, its two wheels are still working and make flour which is sold locally.

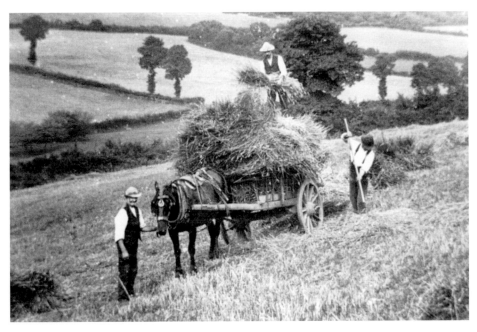

Gathering in the stocks of corn, 1926. Flat land is a rarity in this part of the world and, when the cart is full, it must be with the greatest difficulty that it leaves the field without turning over.

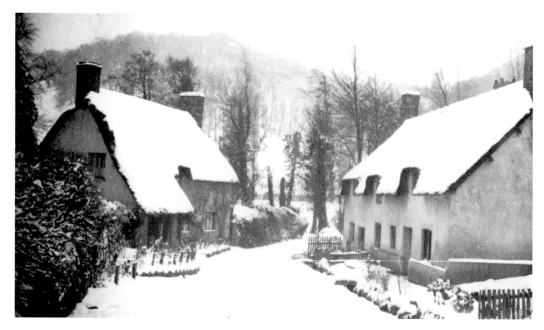

Rose Cottage, 1910. Snow is quite rare in West Somerset and, when it comes, it must be photographed. Here is the beautiful Rose Cottage – before it had to bother about burst pipes. This was perhaps the only compensation for having no running water.

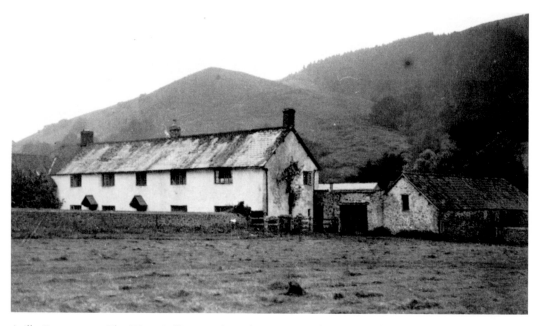

Aville Farm, 1930. The River Aville runs through Dunster and, just outside, on the main road to Timberscombe, is the tiny hamlet on its banks that bears its name.

three

Selworthy

A cottage on the green.

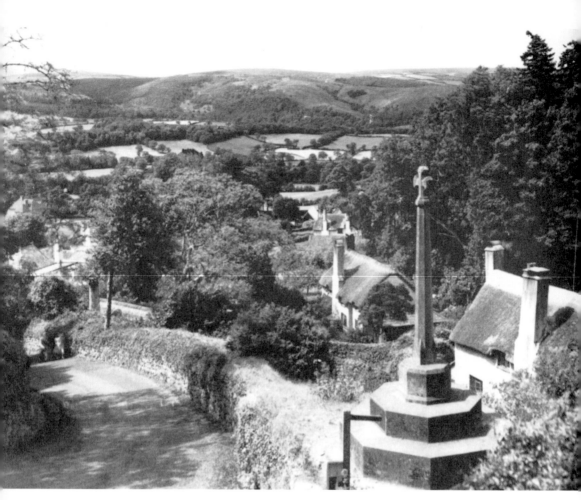

This village must be thought of as a whole and not as any single cottage, for this is how most of it was built. It was primarily for the retired workers from the Acland estates and is now, along with the other Acland lands in the vicinity, owned by the National Trust. It is superbly set in the fold of the hills and it is difficult to imagine, seeing the village today that all the photographs in this section were taken before 1918. Little change has come to the village, which is still without shop or public house.

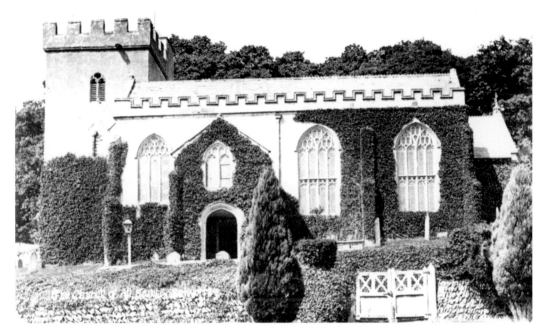

High above the village Selworthy Church is a landmark for miles around. Now bereft of its ivy and painted white, it is strangely out of place in this thatched community. Standing in its doorway the visitor gets an unequalled view of Dunkery Beacon, the highest point on Exmoor.

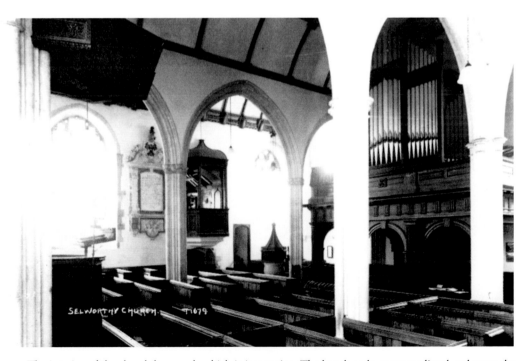

The interior of the church has much which is interesting. The bench ends, some medieval and some the work of a local carving class, are particularly noteworthy.

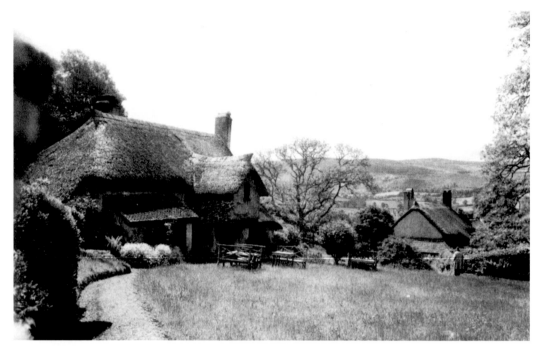

The village green. The large walnut tree which dominated it can just be seen, but this, along with others in the district, has gone and not been replaced.

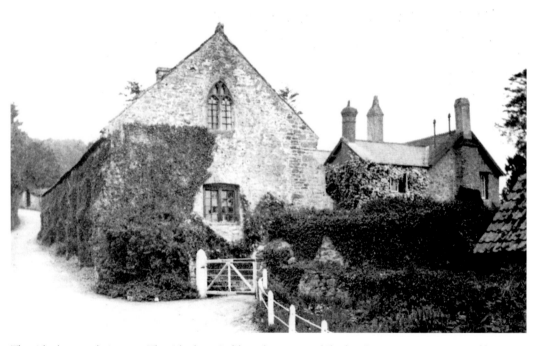

The tithe barn and vicarage. The tithe barn is fifteenth century while the vicarage can trace part of its building to the fourteenth century.

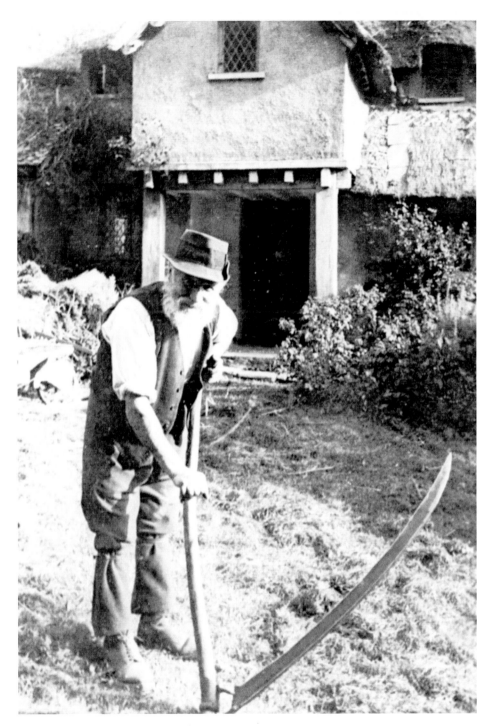

This enormous scythe seems built for more formidable work than the Selworthy grass. I feel that this is yet another of Vowles' scenes of country life for the glossy magazines.

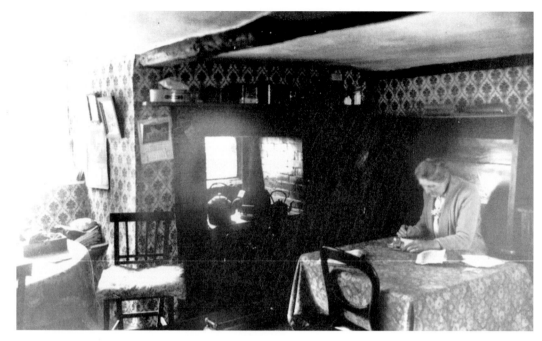

The interior of one of the cottages on the green. The high-backed settle against the right-hand wall was a type very popular in the district. It was said to keep the draughts away while sitting in front of the fire.

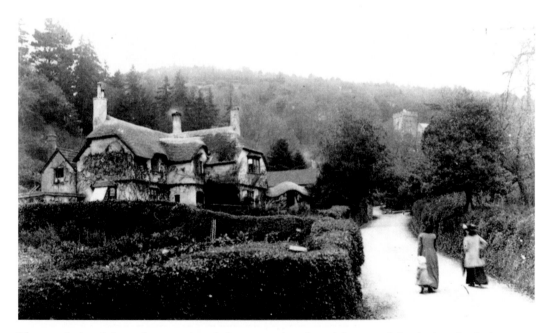

The complexity of the roof patterns here is far greater than that of the normal thatched roofs of other villages.

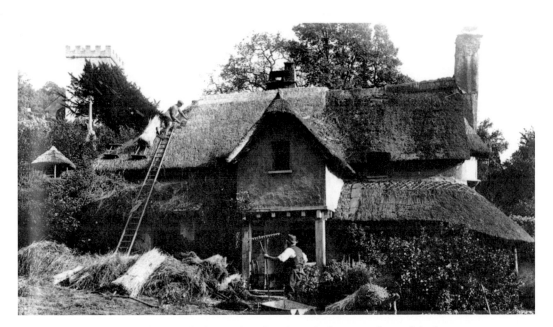

The thatchers at work. Note the huge piles of reeds ready for use in front of the house.

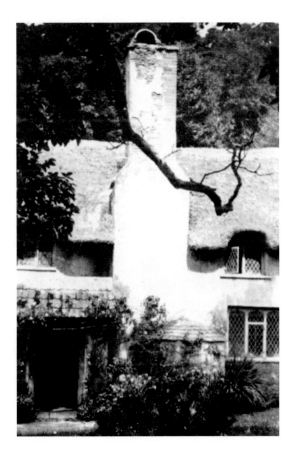

One of the features of a number of houses in Selworthy and the neighbourhood is the large round chimney culminating in the slate-roofed bread oven, which can be seen clearly here.

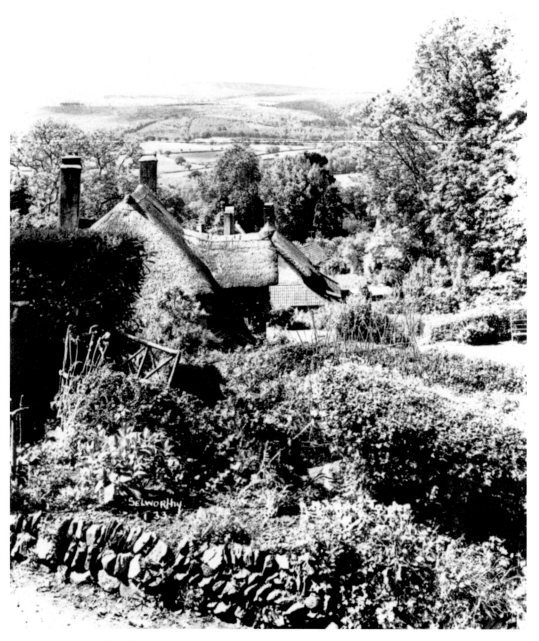

Over the beauty of the village we see Dunkery Beacon.

four

Porlock

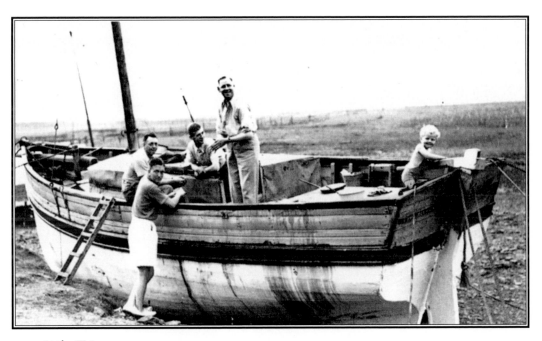

At the Weir, 1935.

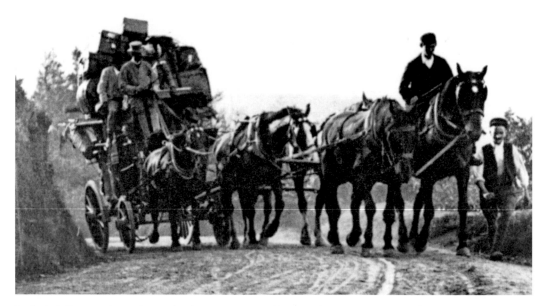

Porlock Hill, 1905. Extra horses haul vast amounts of luggage but no passengers. They were walking up: very often they were even required to push.

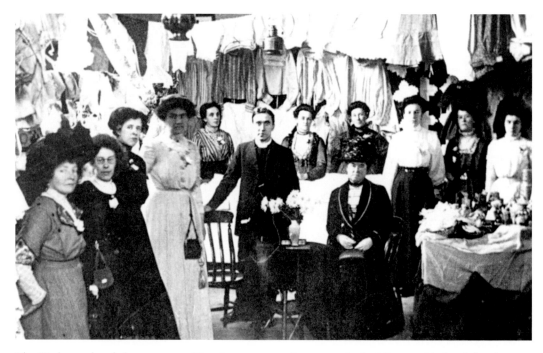

The Wesleyan church bazaar, 1912. The clergyman stands unperturbed while over his head dangle undergarments of all descriptions.

St Dubricius Church, *c.* 1910. A local legend says that the top of the spire was cut off to give tiny Culbone Church its little steeple. Another says that fires were lit on the flat top to guide boats at sea.

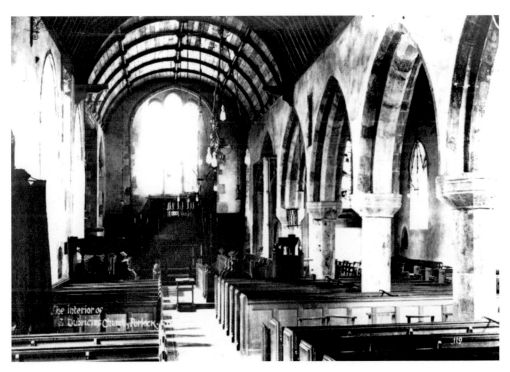

St Dubricius, *c.* 1910. The octagonal piers to the bays are thought to date from the thirteenth or early fourteenth century. The photograph can be dated to around 1910 by the electric light bulbs which can be clearly seen.

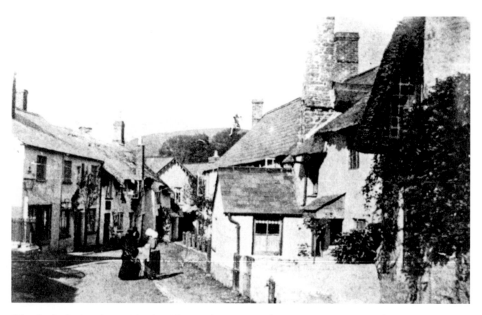

'The Porlock that is past' is the title Vowles gave to this 1910 picture and, if you stand by the churchyard wall, look towards the Lorna Doone Hotel and compare what you see with the photograph, you will not see anything you can recognise.

Doverhay, Porlock, 1911. Smoke from the household fires begins to gather over the winter scene.

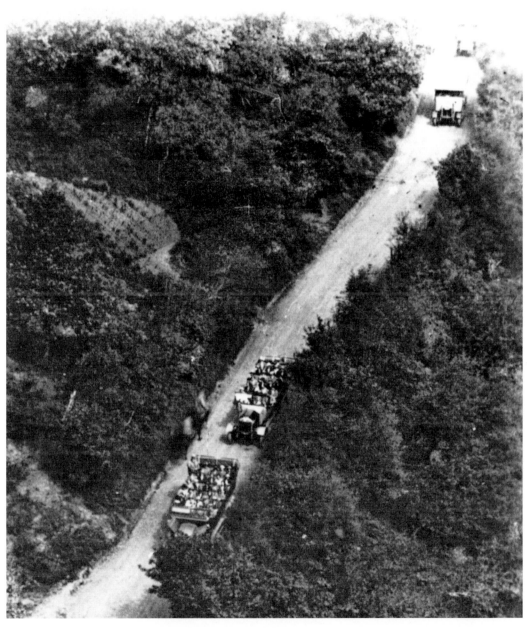

Porlock Hill, 1925. This is THE photograph of the hill, but it is posed. Vowles tells the story thus: 'He wanted to take a photograph of motor coaches descending the steep gradient between Knapp Corner and the bottom hairpin bend (about) which the coach proprietor had given him the word. This entailed a very steep climb through undergrowth for quite half a mile to a point where the coaches could be seen descending on the opposite side of the valley. The drivers had been told that A. V. would be in a position waving a white tea cloth. At last the first coach came round the top bend very cautiously, the rest all in line and equally spaced, then A. V. signalled them to stop, although it must have been a terrible strain on their brakes. After taking the views he blew his whistle and waved them down the hill. These coaches were full of tourists travelling from Lynton and Lynmouth to Minehead Station.'

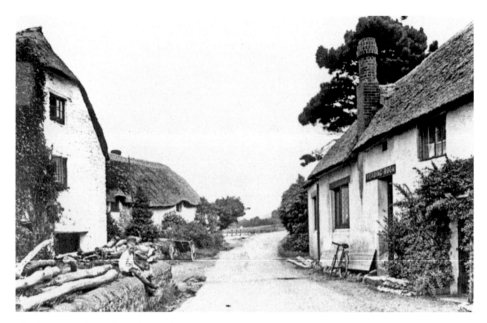

The house on the right is the reading room, Porlock Weir, 1911. It is still there as a private house and can be seen just after passing the main car park on the way back to Porlock.

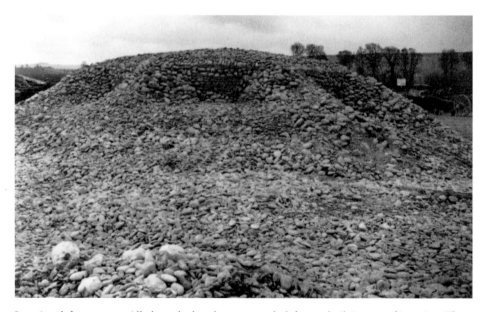

Invasion defences, 1939 All along the beaches were such defences, built in case of invasion. These near the Weir are new and the horses and carts used to bring the stones from the beaches can just be seen. Photography of such things was strictly forbidden: why Vowles, who was the greatest patriot, took such a risk we shall never know.

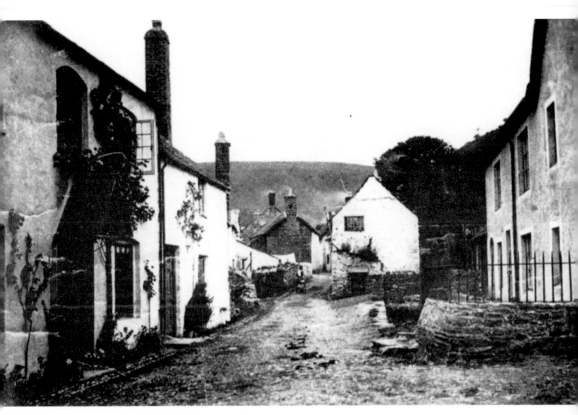

Parson Street, *c.* 1914. It is almost unrecognisable today, but it was here that Vowles had a brush with a murderer. Here, in his own words, is the story: 'At Porlock in 1914 A. V. was closely associated with what became known as the Porlock Murder, when a villager hidden behind bushes in his garden shot and killed his neighbour when he passed by in Parson Street. A love affair? A. V. was close to the line of fire but fortunately escaped injury. He helped to move the victim into his cottage, then ran for Dr Boyle and the village policeman named Greedy. A. V. already had negatives of the murderer, the murdered man and his wife, the cottage, the street, the schoolgirl Alice Middleton who was injured by stray shots and the policeman. These were quickly looked out and sent by rail from Minehead to a Fleet Street agent for the press who devoured them, particularly the sensational Sunday papers. It was A. V.'s biggest coup to date ... The murderer was the last man to be hanged in Taunton Jail (other sources disagree with this). He was a rough boozy sort of fellow and was nicknamed 'Pickerell' because he had a bet with another Porlock fellow that he would swallow at one gulp a whole jar of mustard pickle – he won! This vulgar proceeding was typical of the period and shows in detail how the rougher elements in an isolated village amused themselves.' Unfortunately the press did not return his negatives but the scene of the bloodshed is on the right.

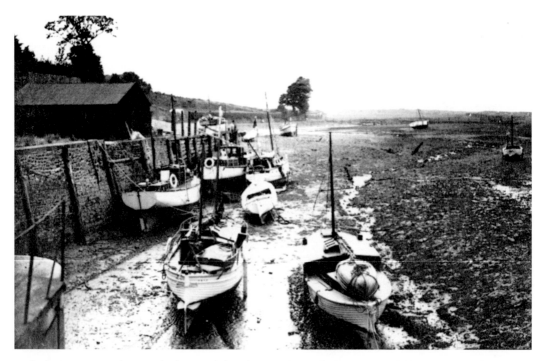

Porlock Weir, 1930s. If mining had succeeded in the Brendon Hills this port would have dominated the district. Plans were afoot to ship the ores from here via a railway, of which only a few feet were ever laid.

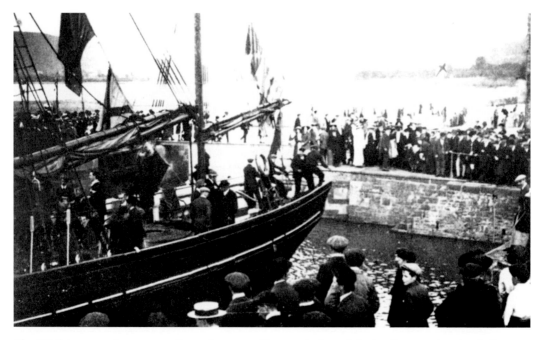

The *Mistletoe* comes home on 15 September 1913. She was the last of the locally owned traders built in Plymouth in 1890 for Thomas Ley of Coombe Martin. He subsequently moved to Porlock and sold her in 1927.

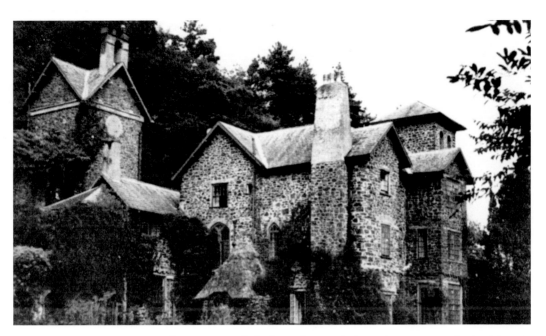

Worthy, 1938. Ashley Combe was originally built as a hunting lodge and summer seat for Lord Byron's daughter, the Countess of Lovelace. It boasted beautiful Italian gardens and most curious tunnels leading to the house, of which the rather poor quality picture below is the only record that I have seen. After the family left, the house had a chequered career. Before the Second World War it was a country club; during the war it was a safe haven for Dr Barnardo's little ones and, when the Americans left Taunton, it sheltered the children that had been born to them. As peace returned no use could be found for it and it was pulled down. The tunnels existed for many more years but have now been removed.

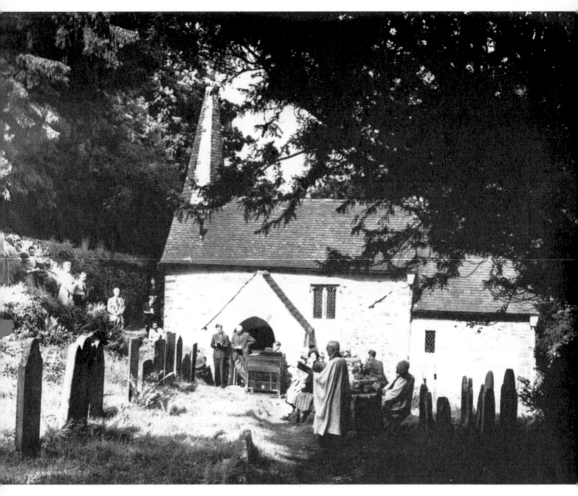

Culbone Church, 1930. England's smallest parish church. Alfred Vowles married there in 1930 and, in 1932, his son Rowland was born. The baby was christened at Culbone in the August of that year. Vowles relates: 'To have a baby christened at Culbone meant a walk of more than a mile along a stony track through the woods from Ashley Combe. Rowland was carried this distance first by his mother, then by his father, then by his uncle Leonard, a broad shouldered six footer who was come down from Yorkshire to act as Godfather. After the usual afternoon service the congregation stayed for the christening ceremony which was very gracious of them.'

five

Exmoor

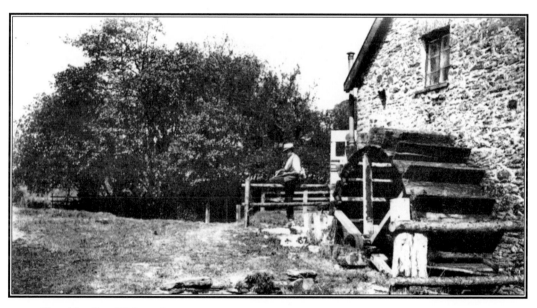

The old mill at Withypool.

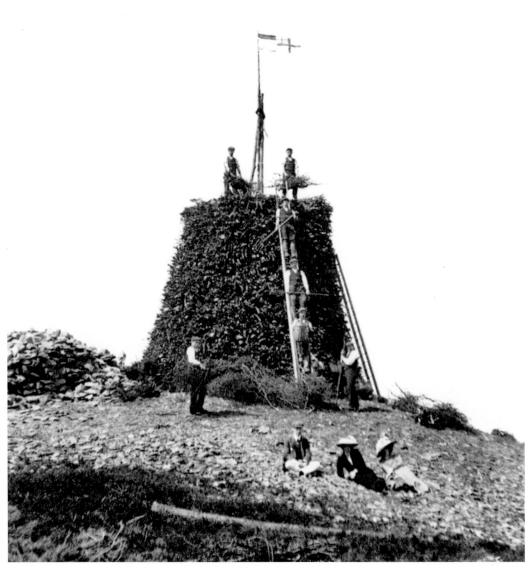

Dunkery Beacon, the highest spot on Exmoor, 1911. It is the site of a beacon, one of the series which are lit on occasions of celebration or warning. Here the fire is being prepared for the coronation of King George V. Vowles rode up on his bicycle to photograph this, carrying the plate camera and tripod. He was at this time still living and working in the caravan at Porlock.

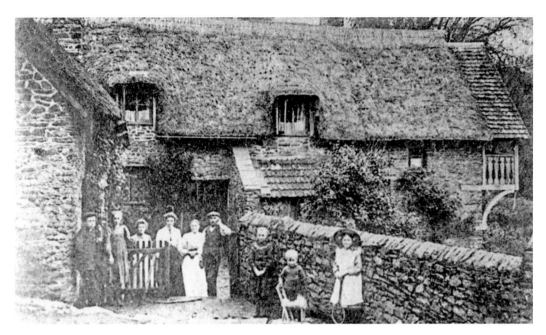

Cloutsham Farm, pre-1912. 'At the picturesque farm house welcome refreshment may be obtained. Close by is the famous Cloutsham Ball, a field in which, early in August, is held the opening meet of the Devon & Somerset Staghounds ... here resort thousands of people, of which hundreds are on horseback and many more in cars. It is a huge picnic, unique among hunting scenes in the world' (1912 guide book). The thatched farm was destroyed by fire but rebuilt about this time.

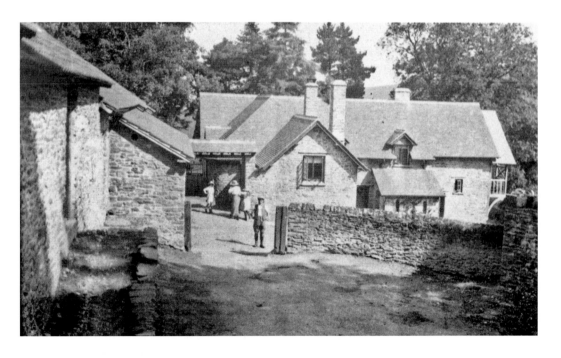

Cloutsham Clammer, 1920. A single rough log crosses the stream with a flimsy rustic handrail: could the name be a derivative of 'clamber'?

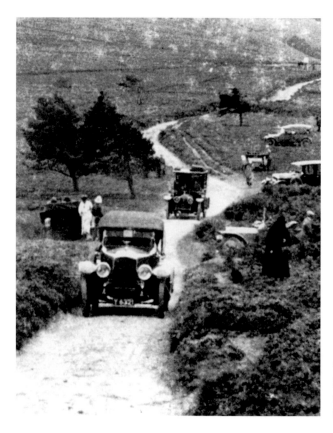

Webbers Post, the motor rally. Unfortunately the photograph is not dated, but it must have been taken between 1910 and 1914.

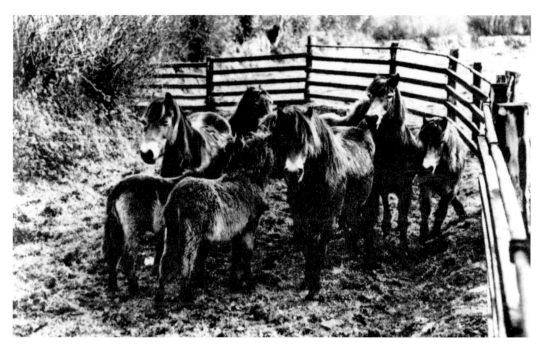

The Exmoor pony is thought to be one of the purest breeds of English wild animals surviving today.

The Exmoor pony, *c.* 1920. Every October it was the custom to round up a large number of these wild ponies and sell them at Bampton Fair. Such was the panic of these wild creatures, when driven through the streets, that people boarded up their windows on fair day.

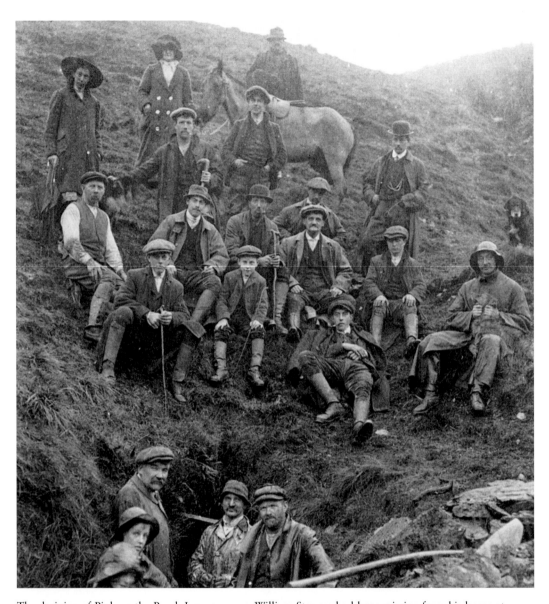

The draining of Pinkworthy Pond, January 1913. William Stenner had been missing from his home at White Cross, Exmoor, since August 1912 and it was supposed that he had drowned in the pond. A team of men led by Mr J. Kingdon of Driver Farm and including H. F. Tudball of Ashnott and Alfred Vowles of Porlock, decided to drain the pond. This, being man-made, could be emptied by releasing a large plug of oak from beneath the water line; pipes would then carry the water away on to the moor. The plug was approached by a tunnel sixty feet long and three feet high in the side of the dam wall. To push the plug out into the pond an enormous iron bar was put into the pipe. 'One, two three ... ram', a terrific roar came from the pipe, the plug yielded and black water gushed around the feet of the men in the tunnel. But the volume did not satisfy Kingdon. The bar was withdrawn, the plug re-seated itself. Eight times more the men rammed the bar against the plug until they decided to force the hole open using a hydraulic jack. The jack forced the plug so far, and such a tremendous rush of water came through it as a result, that it upset gear and men: they were lucky to escape injury. Still the plug slipped back. They tried for the last time and finally were successful.

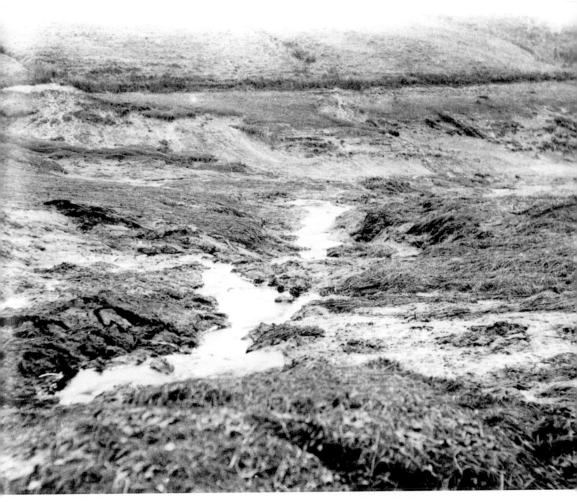

The drained pond, 1913. During the next two weeks the pond remained empty so that the black mud might be fully explored. Vowles wrote to the press: 'In spite of its remote situation and continuous rain a number of visitors were daily seen at the pond, there being no less than sixty there on Thursday. Those that contemplate the trip are requested not to overlook a subscription box near the pond – the Jack mentioned earlier is for sale.' The whole episode, giving exact dimensions and graphic description was sent to the press by Vowles. During the last week in February Stenner's body was found, but not in the pond. It was less than 400 yards from his cottage at Riscombe in a disused mineshaft.

Driver Farm, 1913. This was the headquarters of those engaged in the search for William Stenner and the home of J. Kingdon, leader of the expedition.

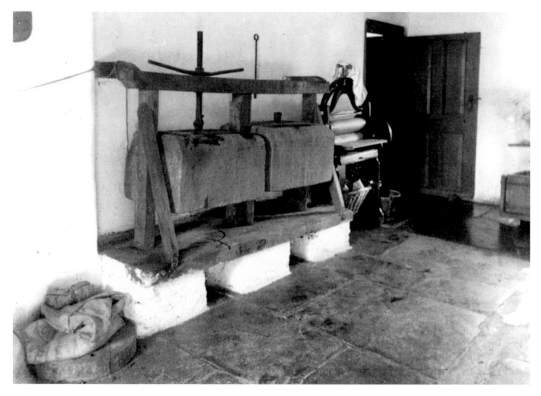

The cheese press, Driver Farm, 1913.

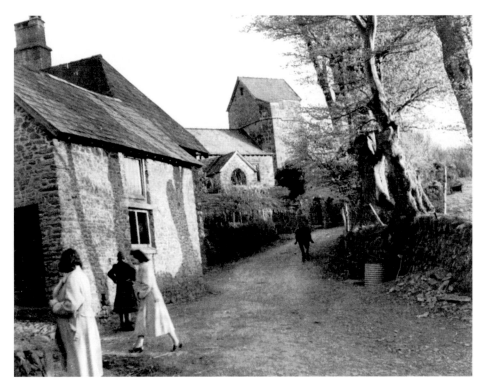

Stoke Pero, 1946. A wild and difficult place to get to, consisting of a tiny church and huddle of cottages. 'Milk, cream and worts (whortleberries – *Vaccinium myrtillus*) go the bells of Stoke church', says the old rhyme.

Exmoor postman, 1905. Vowles gives the name of the postman as Webber, the son of a saddler in the Dart valley. His four sons did a postal round in the morning and worked in the business during the rest of the day.

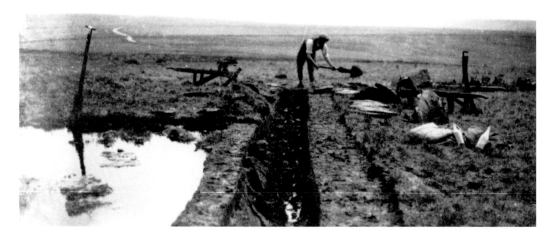

The lonely peatcutter of Exmoor, 1913. At one time peat was burnt in Minehead grates, giving the smoke a particular smell which, when returning from an absence, seemed particularly evocative of the place. There are large areas of bog still, but no peatcutting is permitted now.

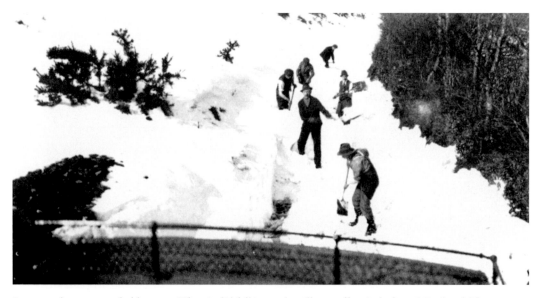

Snow on the moor, probably 1937. When it did fall it cut the villages off entirely from Minehead. There, because of the railway, life could go on as usual. Here Vowles, seated on top of a bus, photographs the men digging a track through the snow.

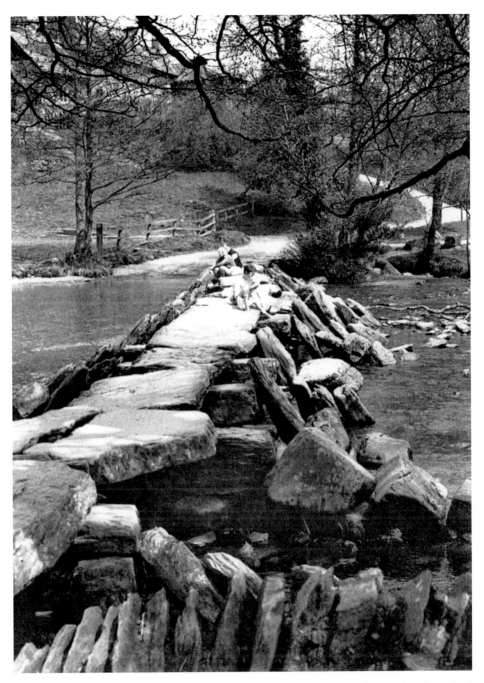

Tarr Steps, *c.* 1935. Throughout the ages this unique bridge has been damaged and repaired. Alfred Vowles had been taking pictures of it since he came to the district in 1905 and, at the end of the Second World War, after storms and neglect had taken their toll, he used his own photographs to supervise its reconstruction in 1947.

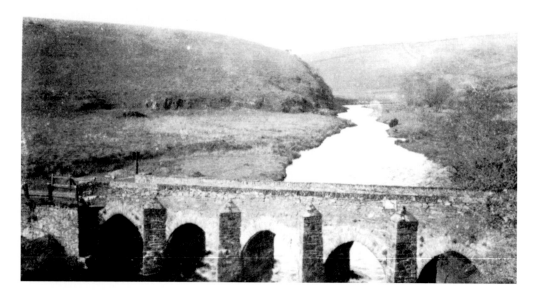

Lanacre Bridge, deep in the wild Doone country, *c.* 1912. It was here that Jeremy Stickles escaped from the Doones.

Pitcombe Cross, 1925. The AA man directs traffic: the door of the AA box can just be seen open. This box still exists as a listed building and is the only one left in the country.

The Villages Around

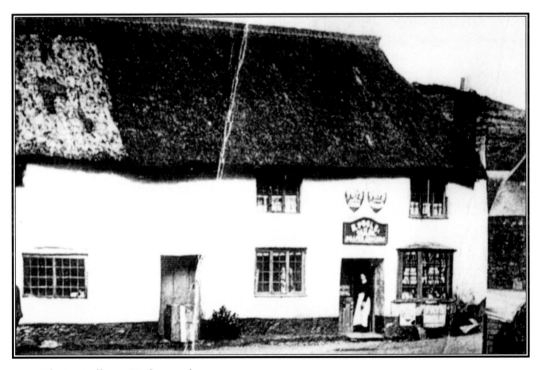

The post office at Timberscombe.

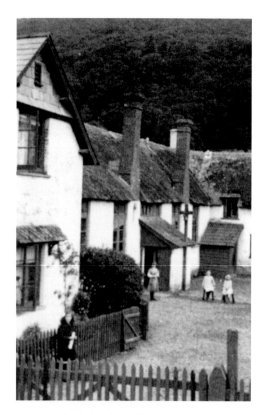

Allerford, *c.* 1935. The little thatched school, standing on the banks of the stream next to the village blacksmith's: such a setting for the start of a child's education. It closed in 1980 and has since become a museum of rural life.

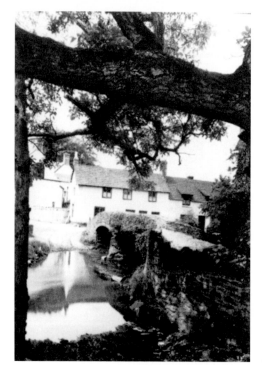

Allerford, 1930. The packhorse bridge and ford.

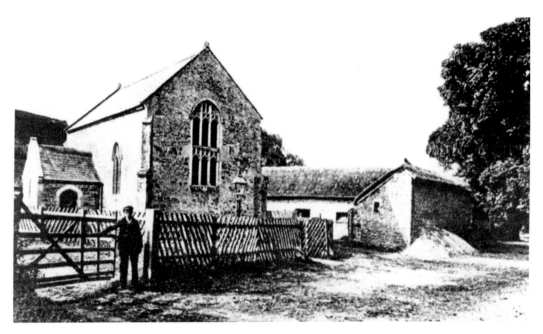

Lynch, 1930. A little further up the road from Allerford is the hamlet of Lynch. It now consists of a zoo, a converted malthouse and dwelling and this tiny chapel. The chapel was built in 1530 but for many years was used as a barn by the next door farm. It was restored in 1885.

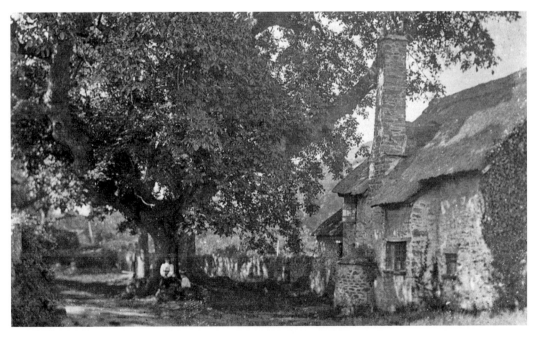

Bossington, 1880. This couldn't have been taken by Vowles but it was among his negatives and shows to perfection the famous walnut tree. It is said that walnut trees were grown to make musket stocks and that there were many around the district. These are now, alas, all gone.

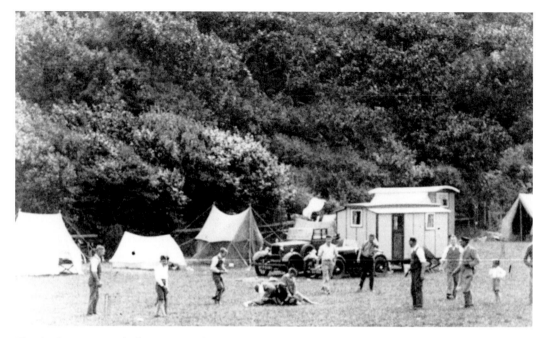

Blue Anchor, 1928. In the late twenties the open-air life was enjoying a vogue; tents, caravans and beach huts crowded this long stretch of beach with fields down to the road. Today the terrain is unaltered but the caravan reigns supreme. The steam railway link from Minehead to Blue Anchor was the first section of track reopened by the West Somerset Railway on 28 March 1976 (see p. 56, top).

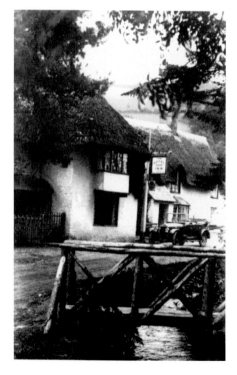

The Royal Oak, Winsford 1935. The Rolls-Royce outside indicates that it was always the haunt of the well-to-do. It is said these days to be visited by The Prince of Wales but on 5th February, 1995 it was severely damaged by fire. Now fully restored it survives to welcome many more of its admirers.

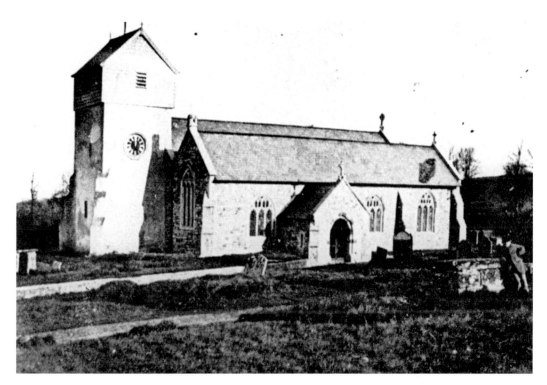

St John the Baptist Church, Carhampton. The top picture is pre-1870, for it was then that the tower was altered. Inside the beautiful rood screen is painted in its original colours of red, blue and gold. In 1994 a burial site was discovered near to the church: this could cause us to revise our thinking about the early history of this neighbourhood.

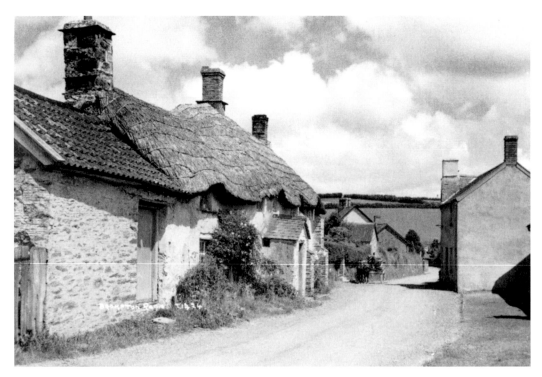

Brompton Regis. This village is so altered that it takes a modern picture to show where we are, as everything in the 1935 picture is gone. The village hall, on the right below, was built in 1914 but entirely rebuilt in 1984. Behind the cottages on the left King's Brompton sheep fair was held each October.

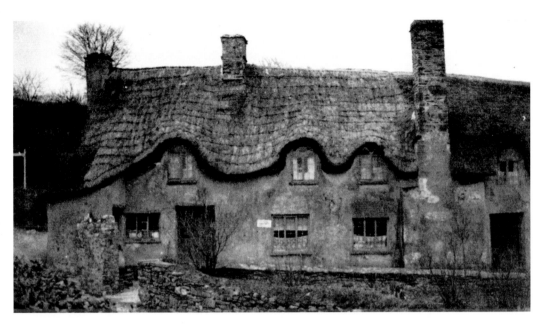

The New Inn, Brompton Regis, 1920. It was burnt down in 1936 and not rebuilt.

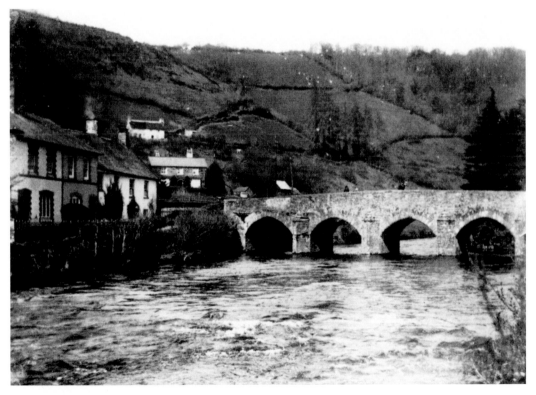

The bridge over the Barle, Dulverton, c. 1912. This has overflowed so many times here causing disastrous flooding to the nearby property.

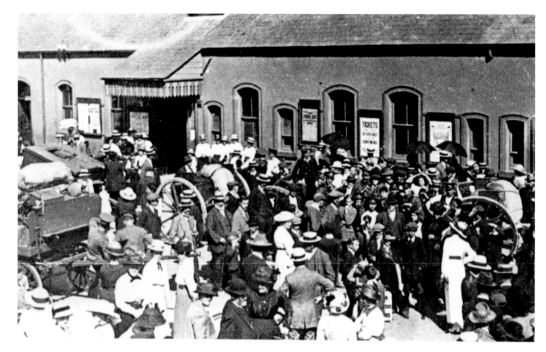

Dulverton station and staff, 1912. Once there was a busy station here on the Taunton to Barnstaple line. Like so many GWR stations it was quite a distance from the town centre and stood opposite the Carnarvon Arms Hotel.

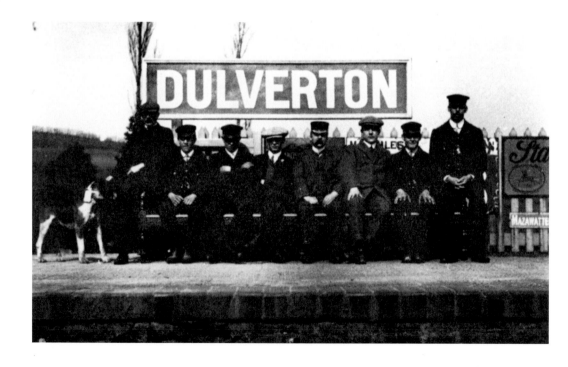

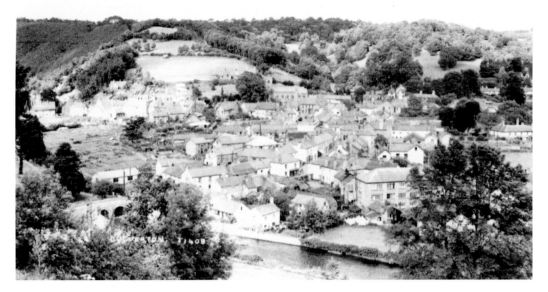

Dulverton, 1912. This panoramic view shows the laundry drying in the open air in a building which started life as a woollen mill, then became a crêpe mill and finally a laundry in 1900. At Ashway Farm was born George Williams, the founder of the YMCA.

Oare Church, 1905. The church where Lorna Doone was shot, in chapter 74 of Blackmore's book of the same name. It is pure fiction of course; the present layout of the church makes the story impossible. The chancel is a later addition, however, and it is said that, before the alterations were carried out, the deed could have been done as described. Every year hundreds of tourists flock here, many believing the tale is fact.

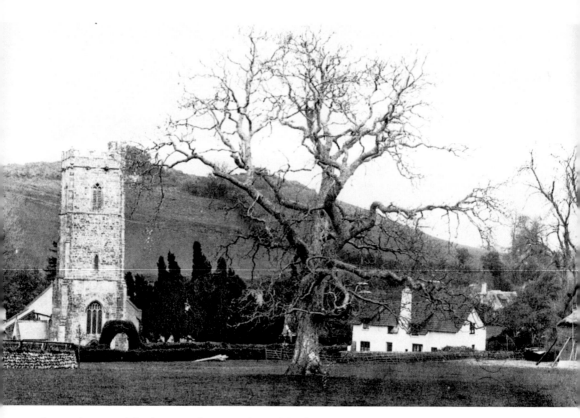

Luccombe, 1914. There is scarcely a more beautiful village in the county, or one whose inner secrets have been so widely broadcast. Here, in 1939, came Mass Observation, that wonderful study that looked into the lives of ordinary people. Naturally it did not come without its problems: neither did the book that followed, although the interior scenes of the cottages were unrivalled as historical documents. Then, in the 1980s, there was a television update of the Mass Observation with the original villagers taking part. Also in the 1980s the BBC filmed a great deal of *The Invisible Man* here and in Minehead, and ITV visited for Walter Wilkinson's true story *The Puppet Man*.

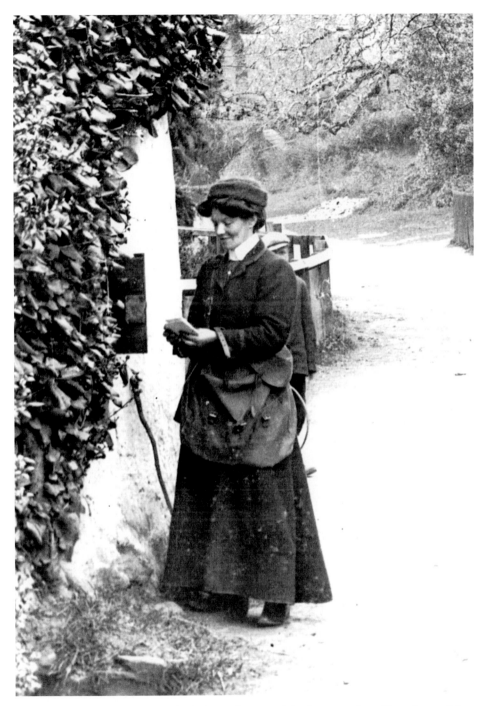

The Luccombe postlady, 1914. The little postbox is still in the same place. Note the small boy with the hoop standing behind her.

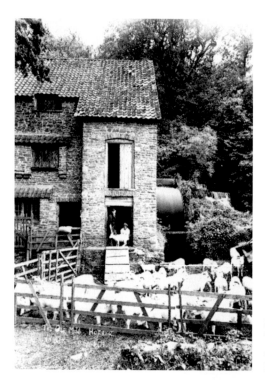

Sheep shearing, the old mill, Horner, *c.* 1908.
The mill still exists but has now been turned into
a private house, although the wheels and leets
have been preserved.

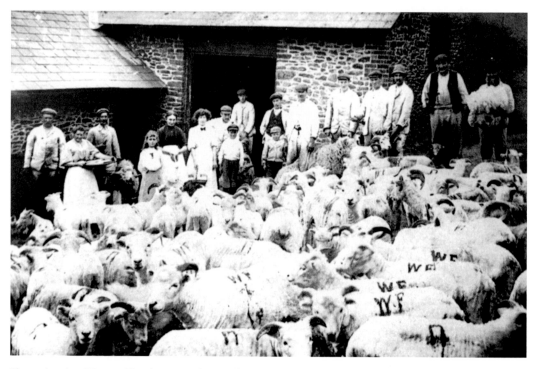

Sheep shearing, Horner. The date is not known but, in the background, you can see a man holding the
old one-handed shears and another with a bale of wool.

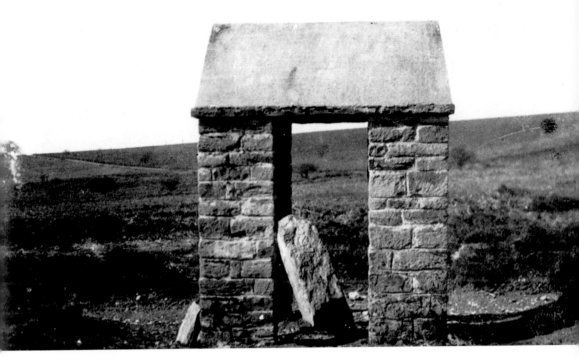

The Caractacus Stone, Winsford, 1937. There had always been a story in the district that buried treasure lay underneath this stone. During the 1930s Alfred Vowles made a study of its inscription and joined in the arguments about what it actually meant. One day in 1936 a friend told him that he had seen the stone lying on its side. Vowles hurried to the spot and reported it to the authorities. It was generally presumed that only those seeking treasure could have disturbed it as vandals would have damaged it. The culprits were, however, never brought to justice. The stone was re-erected the next year and the cover built over it. The opportunity was also taken to confirm for all time that there was not and never had been treasure of any description under the stone.

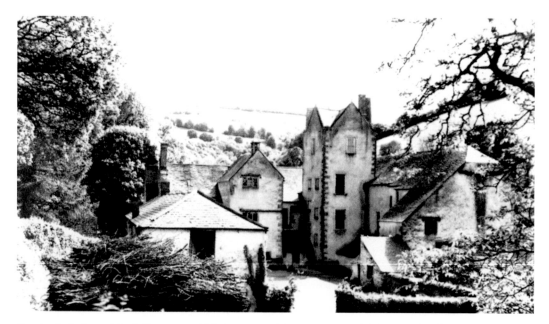

Combe Sydenham, Monksilver, 1935. This is now a visitors' centre and bakery and is famous for its peacocks which roam freely in the grounds. Sir Francis Drake was engaged to one of the Sydenham ladies, a maid of honour to Queen Elizabeth I. His absence was so long that she presumed him dead and was to marry another. On the wedding morn a cannon ball fell between her and her groom which induced her, quite naturally, to give up the idea. It is said to have been fired by Drake from the Antipodes! It weighs 120 lb and returns to its former position if moved. A meteorite is the usual explanation for this occurrence.

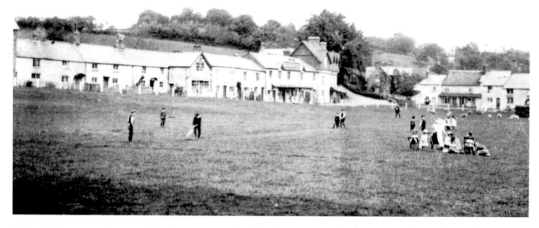

Exford village green, 1907. The boys' game of cricket is attracting little attention from the girls' tea party, or even the sheep. The green is still there, scarcely altered.

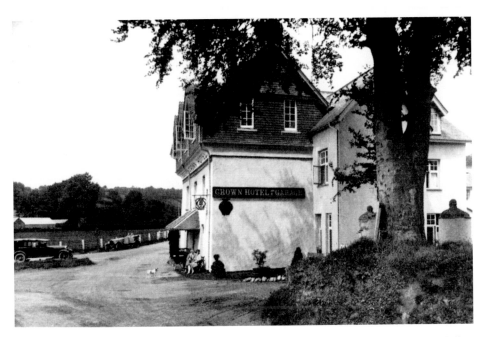

The Crown Hotel, Exford, *c.* 1931. In 1929 the volunteer parties in the hunt for Mollie Phillips were based here. Police, huntsmen and a troop each of cavalry and infantry scoured the moors. Her body was eventually found in the bog of Codsend Moor, but how she died was never discovered: a verdict of death by misadventure was brought in.

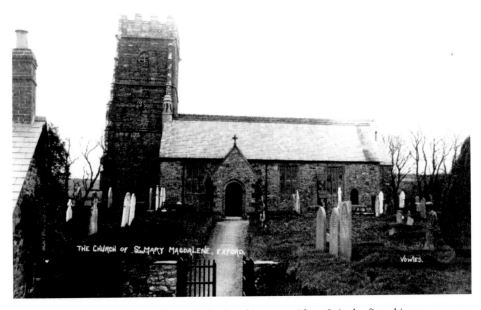

Exford Church, 1921. The position of this church is no accident. It is the first thing you pass as you approach down the steep slope to the village. Here on the high ground it is clear of the floods that regularly threaten the rest of the community.

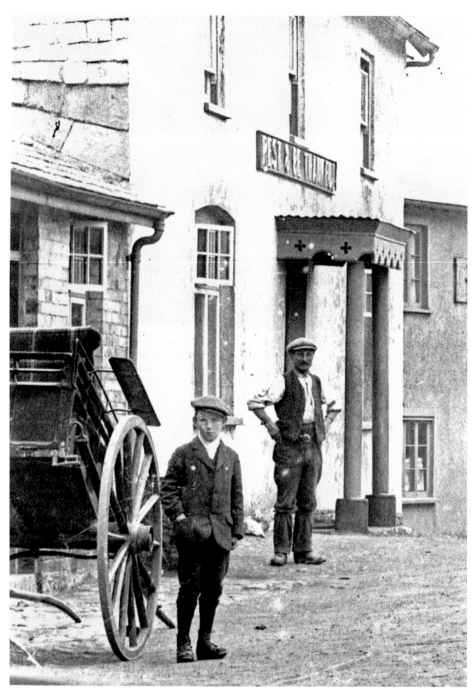

Wheddon Cross, 1912. The carters wait outside the Rest and Be Thankful, which is also the name of the hill. One of the highest villages on Exmoor, the weather always seems a little colder here than in the more low-lying towns.

The Gas House, St Audries. Built in 1855 to a design by John Norton this little building supplied gas to the whole of the estate. In the near vicinity is a hole that once housed a small gas holder. The building has now been converted into a private house.

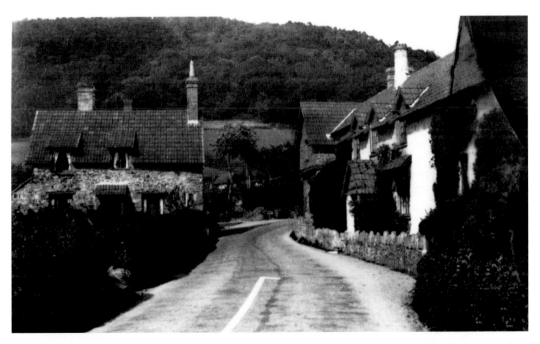

Brandish Street, 1935. Hidden away behind the Porlock/Minehead Road this little hamlet has one claim to fame – a dipping well. This strange stone-built structure on the edge of the village is supposed to be where water was collected for drinking but the awkwardness of the operation, which would have to be conducted on hands and knees, leaves doubt as to its use.

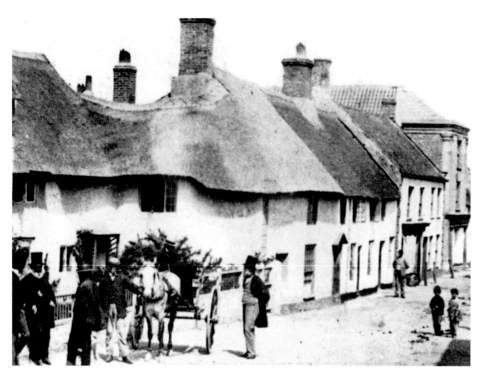

Watchet. Two pictures showing the evolution of Swain Street, although in recent times it has altered yet again. Judging by the fashions, the top picture is from about 1870, the bottom one from about 1914. Get your bearings from the colonnaded building at the end of the row. Anchor Street begins just out of the picture on the left.

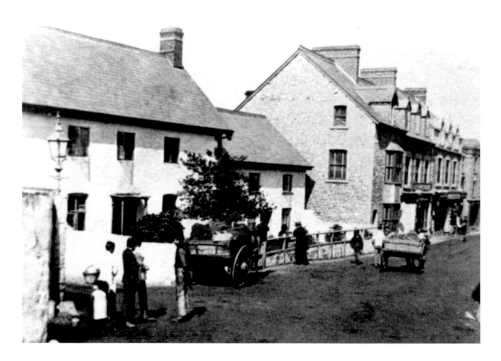

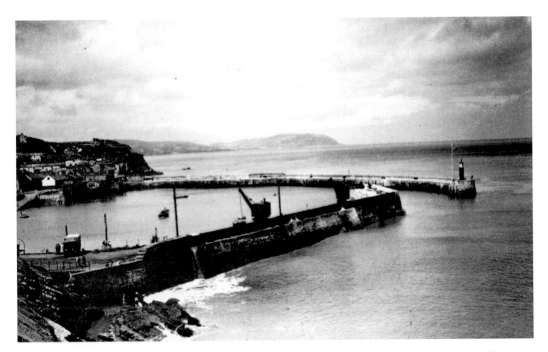

Watchet 1938. This was a maritime town with boats bringing Esparto grass for its paper mill. At one time this quay was the terminus of the Mineral Railway which disgorged its cargoes of iron ores from the Brendon Hill mines to the boats of the Ebbw Vale Company of South Wales.

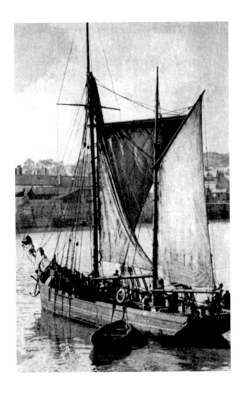

The *Express*, Watchet harbour, *c.* 1910.

Brushford. This parish hall was opened in 1920. A much travelled building, it started life as a Yeomanry Hut from Minehead's Camp Ground. It was moved to Minehead Hospital, where the wounded were being cared for, in the First World War. When the war ended it came to its present site and was clad with corrugated iron to protect it not only from the weather but also from the sparks from the engines on the nearby railway line. The railway has gone and so has the old hall, but a fine new parish hall has been erected on the site.

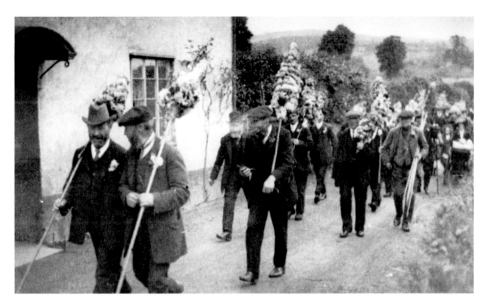

The Friendly Society, Timberscombe, 1908. Members paid a subscription and this was pooled to help each other in time of trouble. On march day the men paraded through the village to church with their flower-decked poles and wreaths. Wives and children followed at the rear. The coming of social security has slowly done away with the need for most of these societies, which were a feature of many villages.

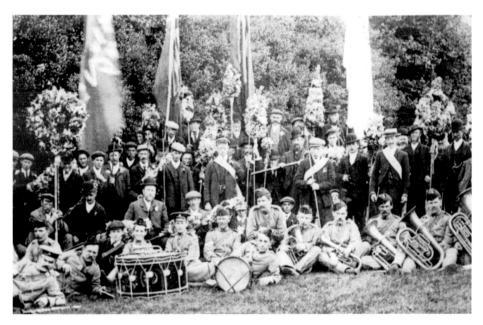

Timberscombe, 1908. The Friendly Society church parade is complete with band, banners and flags. Absentees from the parade were fined 2s 6d. The annual subscription was 3s. There was a strict rule that anyone drawing sickness benefits had to be indoors by 8 p.m.

Acknowledgements

My grateful thanks to my husband Kenneth for printing the glass negatives and helping in so many other ways.

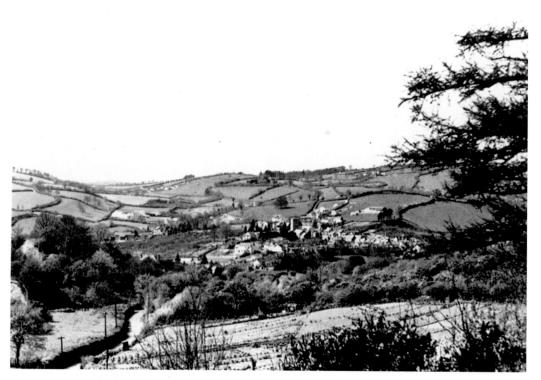

A Bampton landscape.